To Genny
from Lauren
Happy Early Birthday

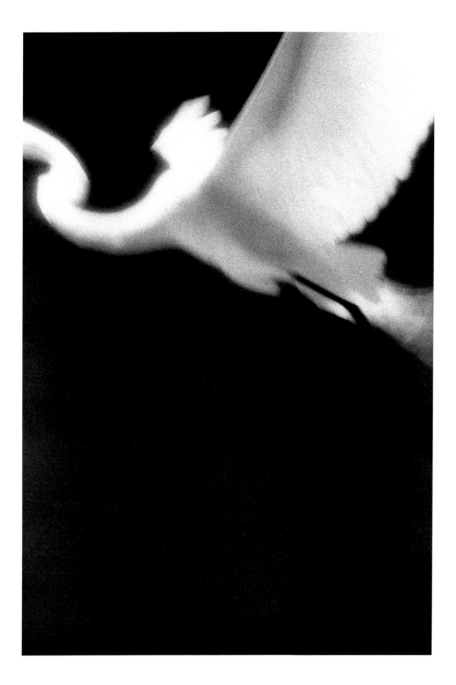

No bird soars too high if he soars with his own wings.

— william blake

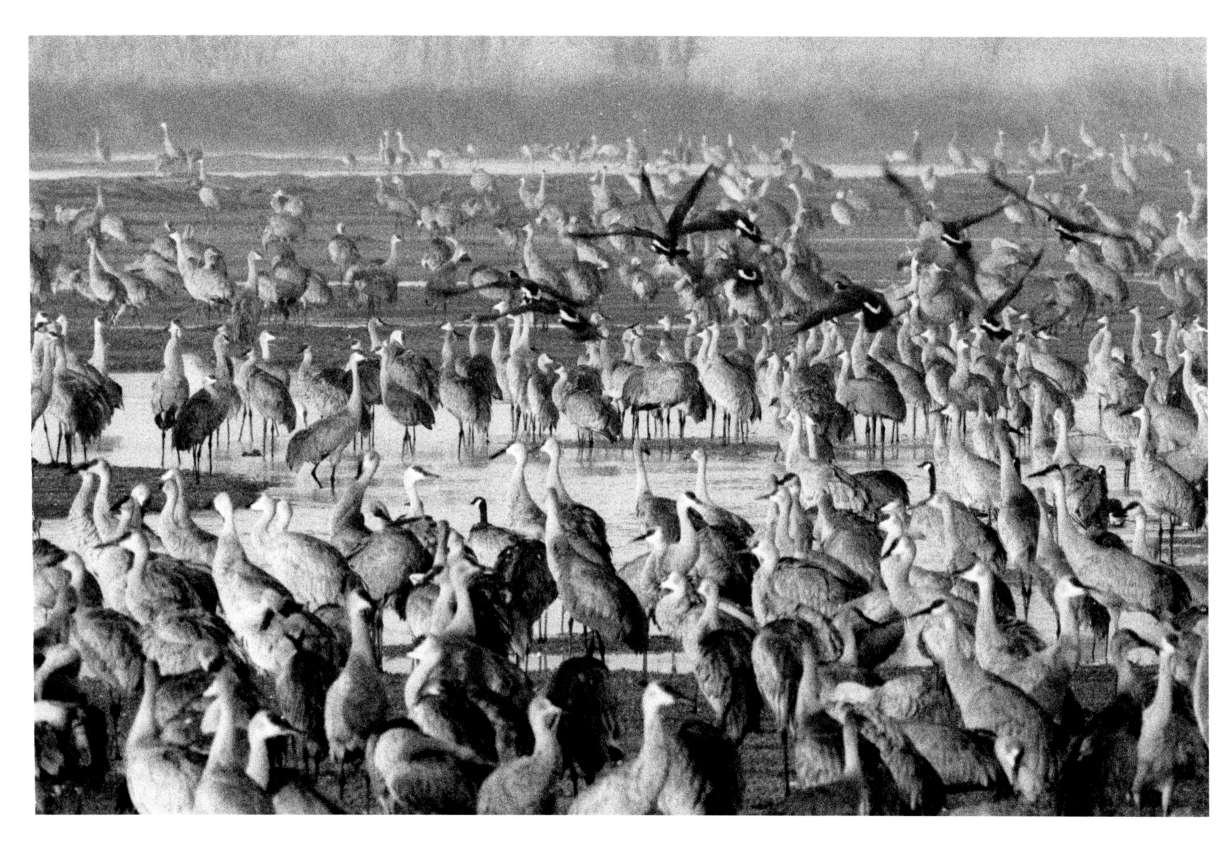

wild birds *of the american wetlands*

photographs by rosalie winard

foreword by temple grandin *essay by* terry tempest williams

welcome books

NEW YORK & SAN FRANCISCO

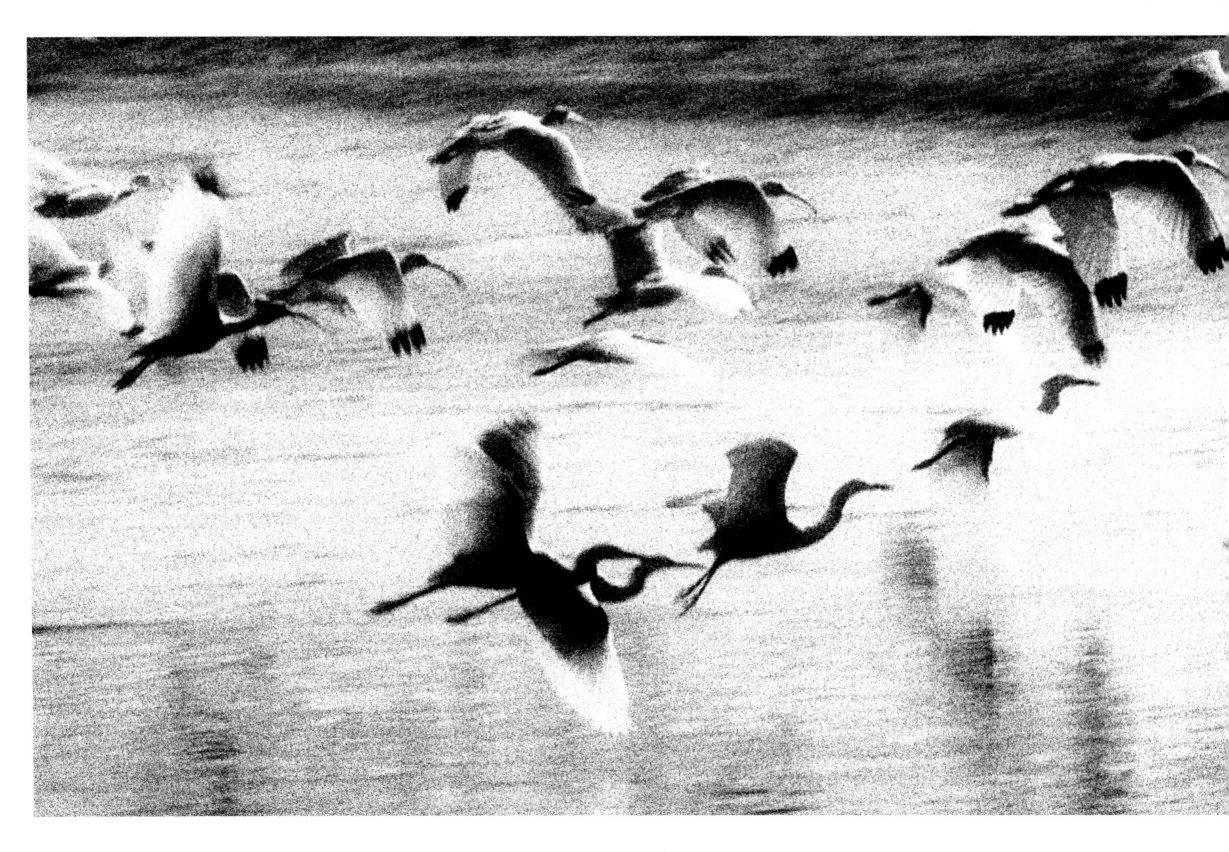

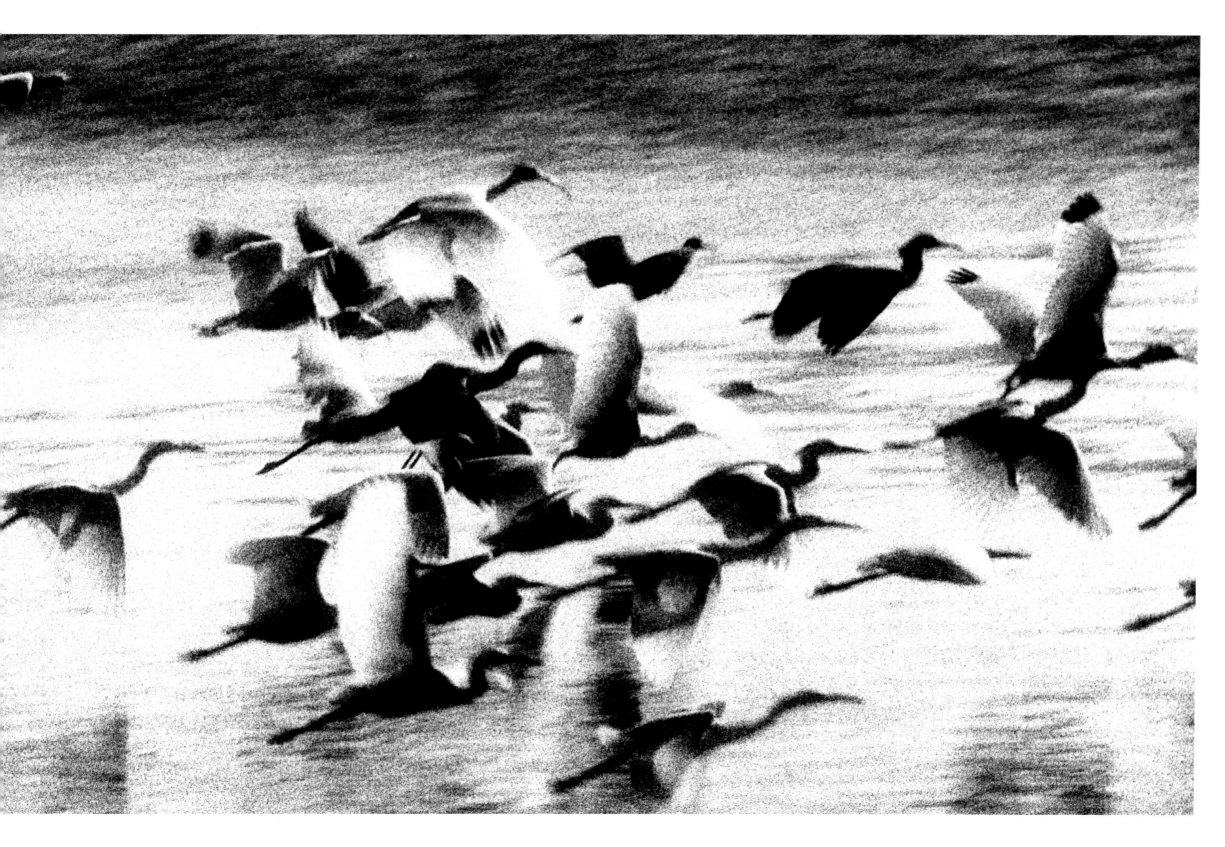

the first bird i fell in love with
was a brown pelican.
i saw it diving
at dawn
into the still waters of sarasota bay.
it looked like he flew out of a paul klee painting.
since that time
my life's passion
has been
herons
ibises
cormorants
cranes
anhingas
avocets
spoonbills
egrets
limpkins
and
pelicans.
if anything
i hope i
reflect
the spirit
and personality
of these birds.
imagine a world without them.

rosalie winard

PRECEDING PAGES: White Ibises, Little Blue Herons, and Egrets, J. N. "Ding" Darling National Wildlife Refuge, Sanibel Island, Florida, 2004 OPPOSITE: Immature Brown Pelican, Longboat Key, Sarasota, Florida, 1999

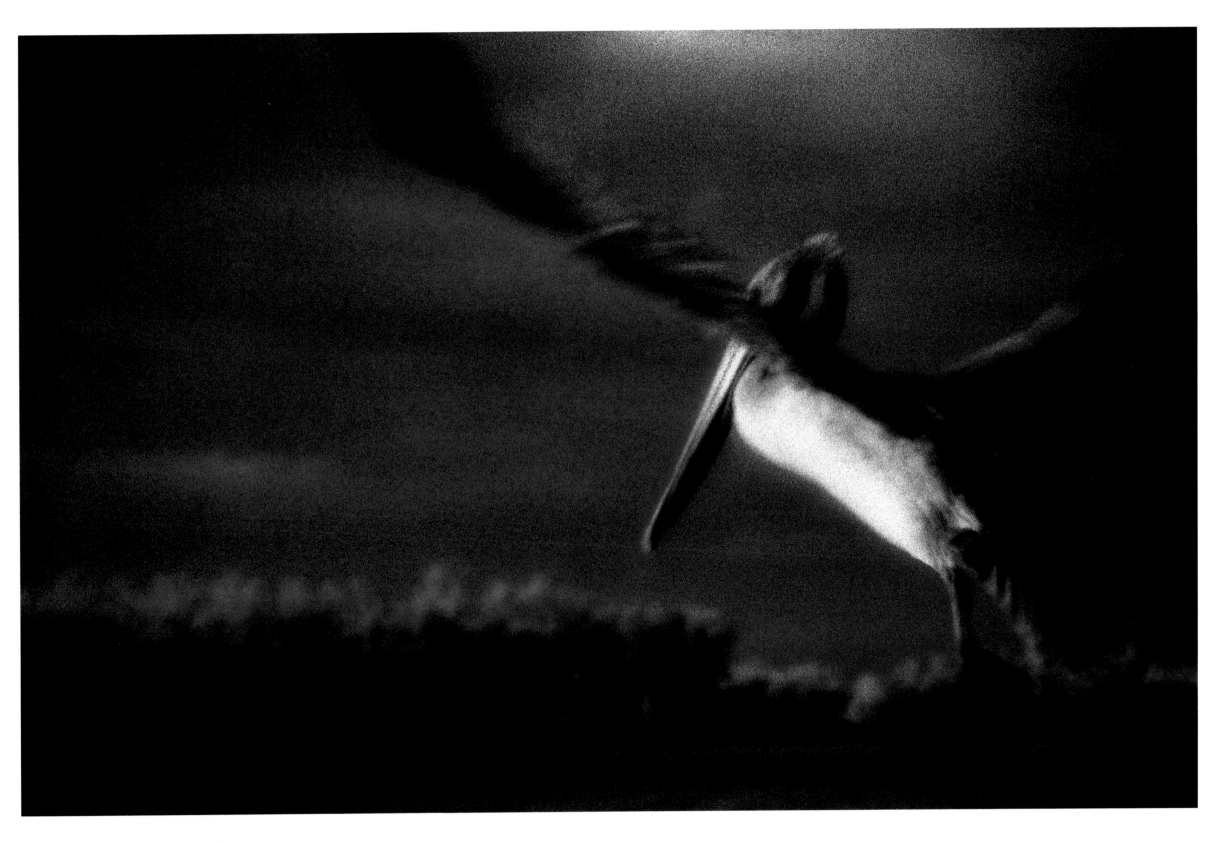

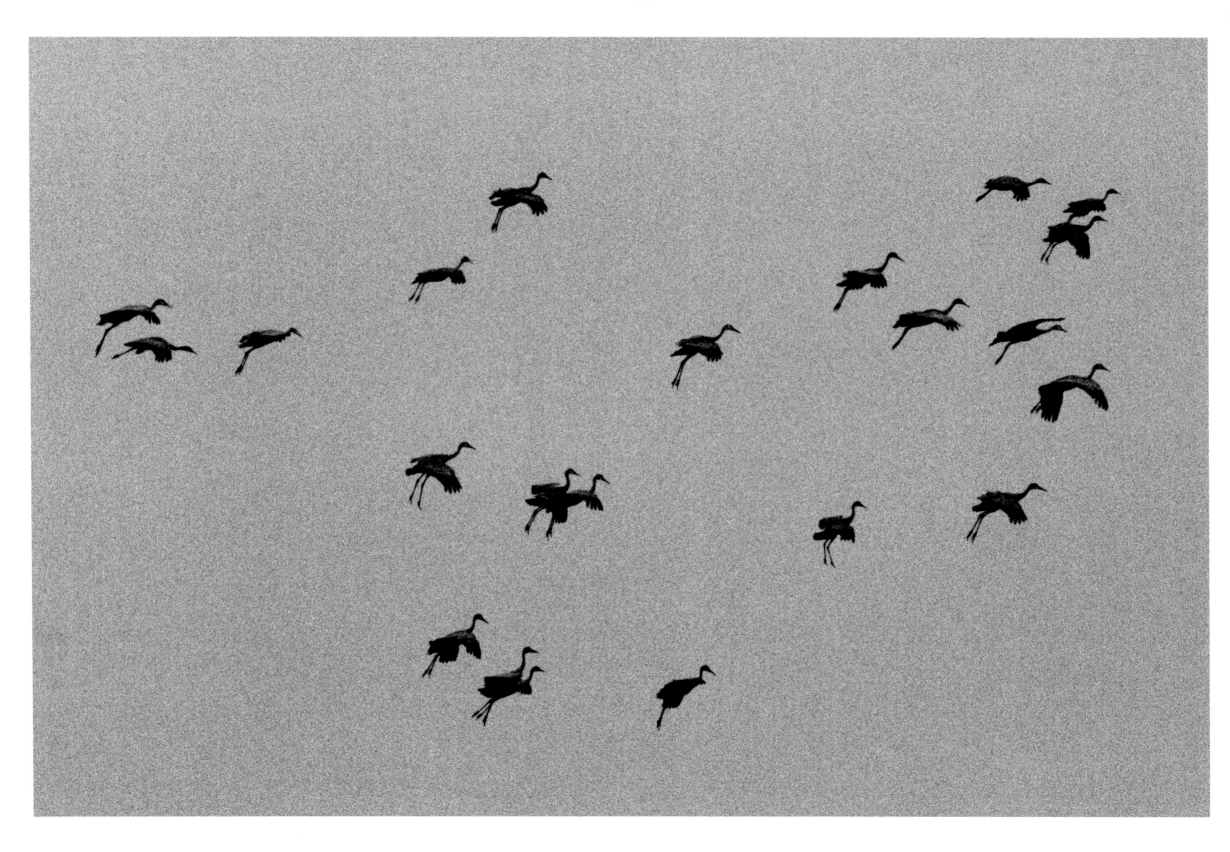

foreword

TEMPLE GRANDIN

When I first saw Rosalie's gorgeous bird images, I thought about angels flying through the night sky. They have the most marvelous ghostly quality. She has added an element of abstraction in her work, mixing emotion and images in a way that I find utterly distinctive.

Rosalie has opened the door for me, and I hope for many others, to experience these birds and their remote and rarely visited habitats in the United States. I hope this book motivates people to protect these beautiful wild birds and their natural wetland homes.

For me, this book is "Birds in Translation."

Sandhill Cranes landing, Platte River Valley near Grand Island, Nebraska, 2003

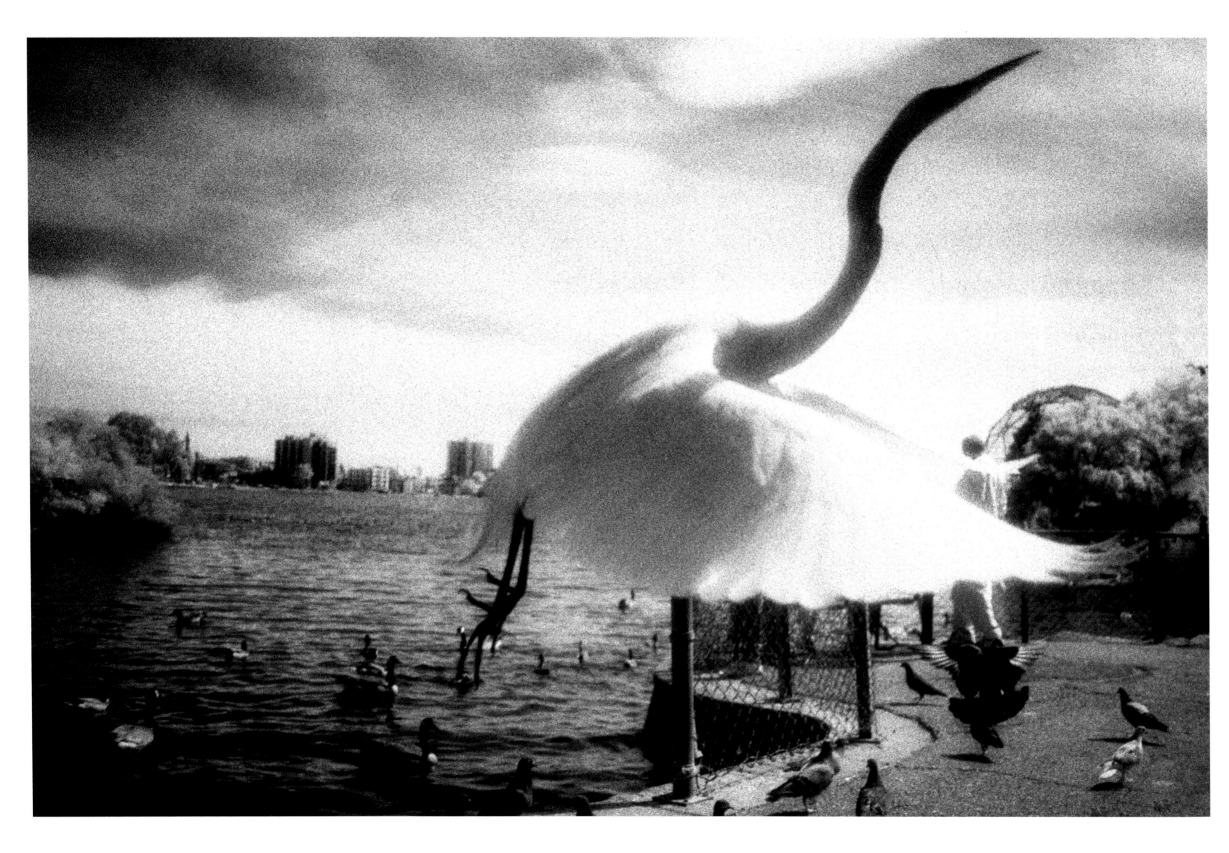

avian primitives

TERRY TEMPEST WILLIAMS

Sometimes the mountain
is hidden from me in veils
of cloud, sometimes
I am hidden from the mountain
in veils of inattention, apathy, fatigue,
when I forget or refuse to go
down to the shore or a few yards
up the road, on a clear day,
to reconfirm
that witnessing presence.

—Denise Levertov, "Witness"

That witnessing presence. This is Rosalie Winard. With a camera in hand and a heart as wide as the country she is seeking, she has migrated in and out of America's wetlands in search of her beloved long-legged birds. By now, after almost a decade of focusing on Avian Primitives—pelicans, herons, egrets, avocets, stilts, storks, ibises, and cranes—she is perhaps more bird than human.

If there was a conference of wings in the wetlands of Great Salt Lake, Rosalie was there. When the sandhill cranes touched down on the Platte River once again in the spring in Nebraska, Rosalie was lying on her back in the prairie, looking upward at nine million years of perfection. And when the wetlands of the Bolsa Chica were rejoined with the Pacific Ocean in a free-flow exchange, Rosalie was there to both document and celebrate the occasion with local activists, who never stopped believing in the power of restoration.

First and foremost, Rosalie Winard is an artist of restoration. Through the act of witnessing these fragile, enduring birds of America's wetlands, she refuses to let their noble and imperiled lives remain hidden. Each image is a reckoning with Other.

Consider the photograph of the Great Egret, wings fanning forward, as it lifts itself over a chain-link fence with the city of Oakland in the background. In spite of our urbanized, industrialized world, these Avian Primitives continue to grace us with their uncompromising beauty.

In another image of the Great Egret, in Sarasota, Florida, it is rising like a winged crucifix out of the frame—its head, eyes and beak clipped. Only an artist who recognizes the redemption of the wild as it crosses and clashes with culture could create such an evocative and disturbing tension: absence and presence, at once.

This tension is further explored in the photograph of a wood stork walking across pavement, again in Sarasota. The shadow of the bird looms larger than the bird itself.

These are shadowed days for North American wetlands and the myriads of shorebirds that inhabit them. These rich waters are being dredged, drained, filled, and developed at record rates. Millions of acres of wetlands have been lost. We are witnessing a fragmentation of ecosystems that will render this continent bankrupt if we don't rise together, hand in hand, and circle these shimmering pockets of water, and say, no, no, no to the wholesale destruction of these quiet waterways that continue to draw the birds downward like a mother.

Nurseries for waterfowl, a natural filtering system for pollutants, and barriers against storms are just some of the native qualities of wetlands we cannot afford to overlook or underestimate.

And if all this is not enough to awaken our awareness, consider that more than one billion people lack access to fresh water and more than two billion people lack adequate sanitation services. Wetlands and rivers are the source of water—a source of life—for all species. This is not just a story about the survival of birds. It is a story about survival, period.

"With already half the world's wetlands gone, we need a new mindset that appreciates wetlands as water's source and storage instead of land to be drained and developed," said Jamie Pittock, Director of World Wildlife Fund's Freshwater Program.

Who is watching?

Again, I look to one of Rosalie's images: Black-crowned Night Heron. A portrait of a gaze, penetrating and piercing.

What if we quieted ourselves long enough to listen to the collective wingbeats of avocets and stilts flying across Great Salt Lake?

What if we were able to locate a stillness so sweet and sublime we could hear the prehistoric cries of sandhill cranes rolling across the prairies like thunder?

What if we agreed for one short moment to suspend all manner of mechanical noises: cars, planes, trains, ships, motors of any kind; factories, whistles, horns, bells; even radios, iPods, televisions and cell phones? And we simply made a vow that for one moment on the planet we would try to quiet ourselves long enough to partake of the natural rhythms of the Earth and listen?

What would we hear?

Avian exuberance. The spectacle of wings. The whistling of wings cooling the planet. Our own primal longing lodged deep in our DNA released, revived, restored—we are part of the great breathing heart of Beauty.

We remember what we have forgotten. All life is intertwined.

It is in our shimmering wetlands that sparkle and sing that our Avian Primitives make their stand. Who cannot hear their brackish calls or croaks or murky voices seeping out of the swamps and marshes and not be moved by a presence so much older than ours? Their lineage is linked to dinosaurs. Do they see us as a passing evolutionary disturbance, an aggressive fad, or partners in a dynamic world? There are those who say birds have no thought, only instinct. But if instinct is the cornerstone of survival, then we have much to learn from their primal stance in contemporary times and what it means to adapt graciously in a changing world.

When I asked Rosalie what she has learned in a decade of working with these Avian Primitives, her response was immediate: "The resiliency of Nature. That against all odds, these long-legged birds survive."

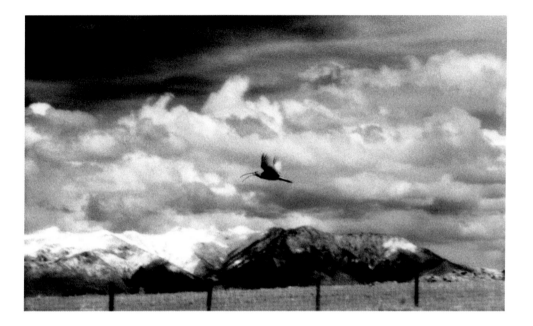

Another one of her photographs enters my mind: Long-billed Curlew crying out over Antelope Island; dark clouds are gathering, an impending storm.

I have always believed that as long as there are Long-billed Curlews in the world, arriving each spring in the grasslands of the Great Basin, I can hold on to hope.

This is Rosalie Winard's greatest gift to us as a fine art photographer, an avian artist. She has created a portfolio of hope. She has taken her artistry and put it in the service of her heart.

"I know what I need to be doing," she told me one night as we were camped together on Fremont Island in the middle of Great Salt Lake. "I know what I want to be doing—spending time with birds." She paused. "They are my joy."

She went on to say that one of the hardest things to reconcile in her life was whether or not she was an artist or an activist. Now, many years later, after migrating north and south, east and west with her beloved Avian Primitives, it is no longer a concern to her.

"It is one and the same," she said to me not long ago in New York City. "My art is my love is my action. I have seen so many wetlands in this country without any birds," she said. "Where are they? Who is watching? How can we not respond?"

"Motion can be a place, too," writes the poet Robert Pinsky. Rosalie, like the birds she photographs, is a woman in motion. Sometimes frenzied, sometimes manic, always intense and driven, home for her these past ten years has been about flight—following her birds like a lover. And therein lies a beautiful paradox inherent in her body of work. Rosalie Winard's *Wild Birds of the American Wetlands* is a work of exquisite calm. Call it the transparency of grace. Through the lens of her great love, she has given us a blessed witnessing of wings.

Days need birds and so they come...

— james schuyler

Brown Pelicans and Western Gulls, Abbotts Lagoon, Point Reyes Peninsula, California, 2004

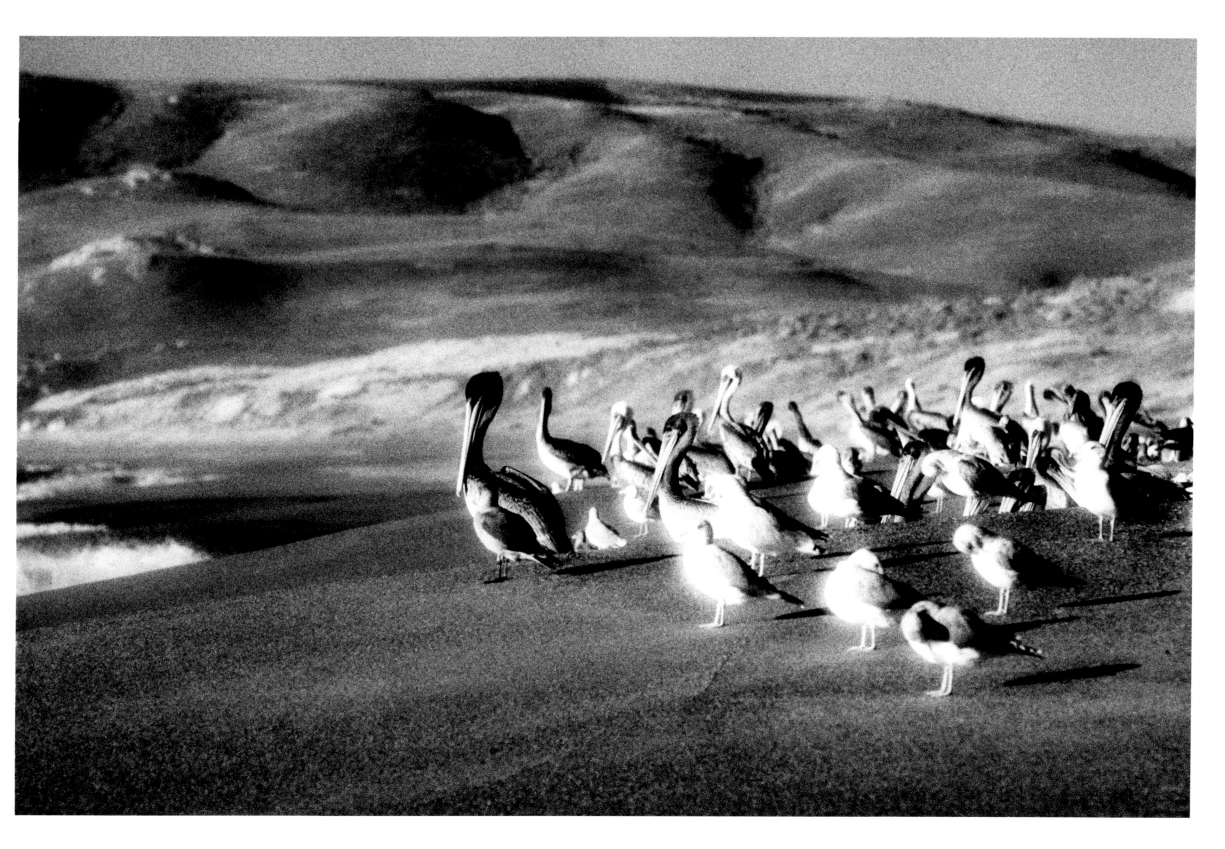

Great Blue Heron, South Lido Beach, Sarasota, Florida, 2002

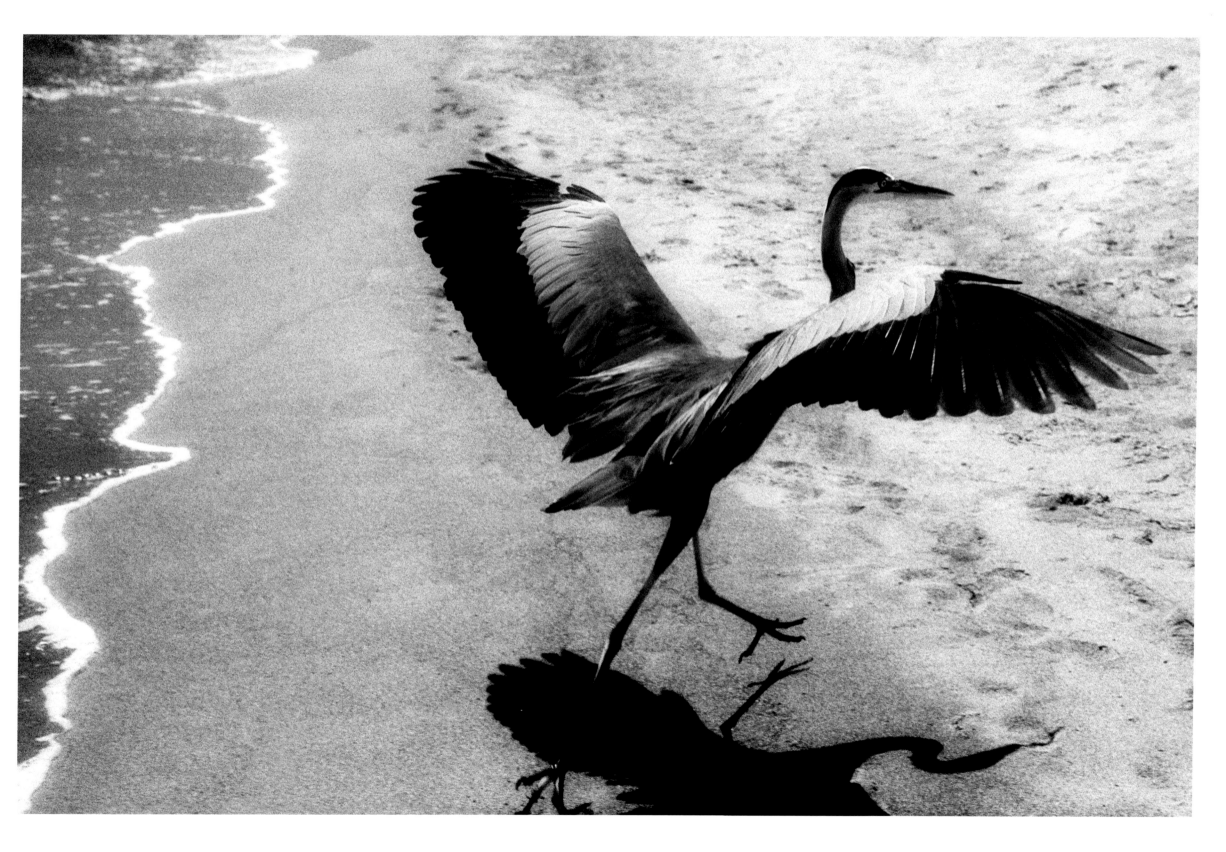

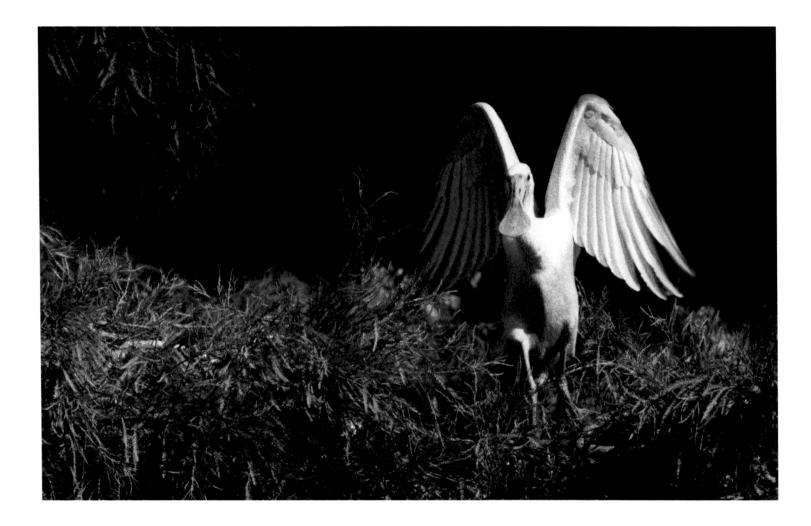

ABOVE: Roseate Spoonbill, Lake Martin, Breaux Bridge, Louisiana, 2004 OPPOSITE: Brown Pelican, New Pass, Sarasota, Florida, 1998

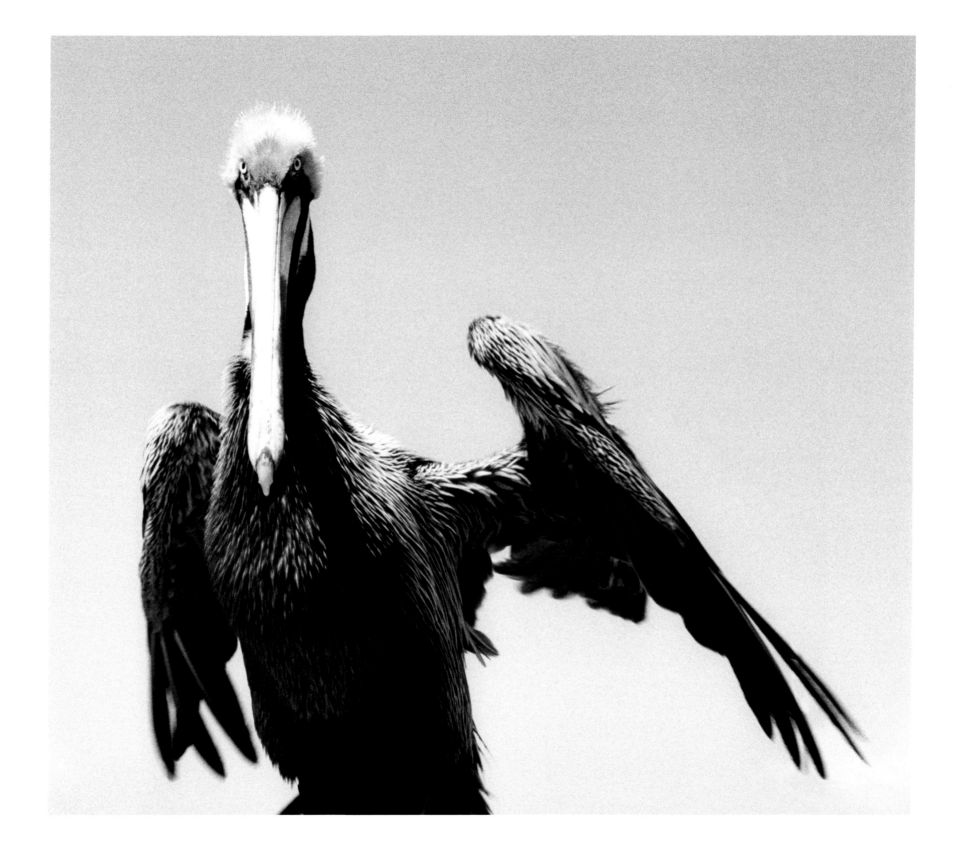

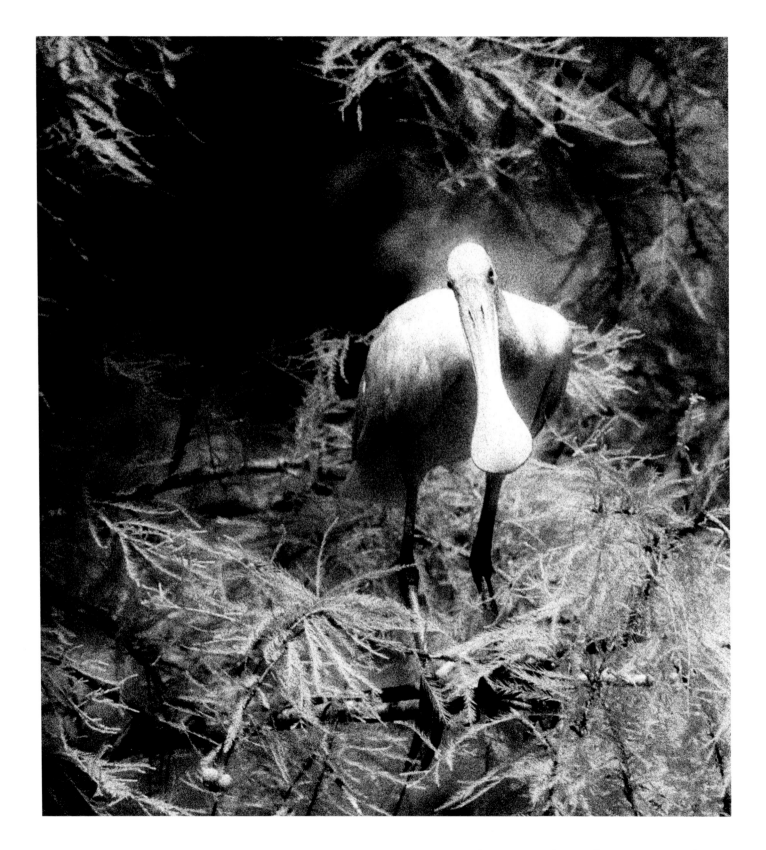

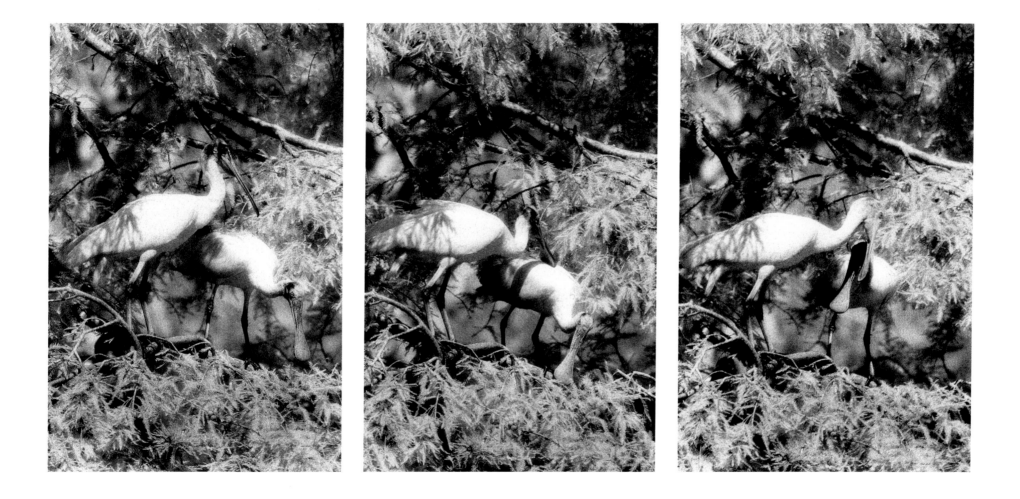

Roseate Spoonbills, Lake Martin, Breaux Bridge, Louisiana, 2004

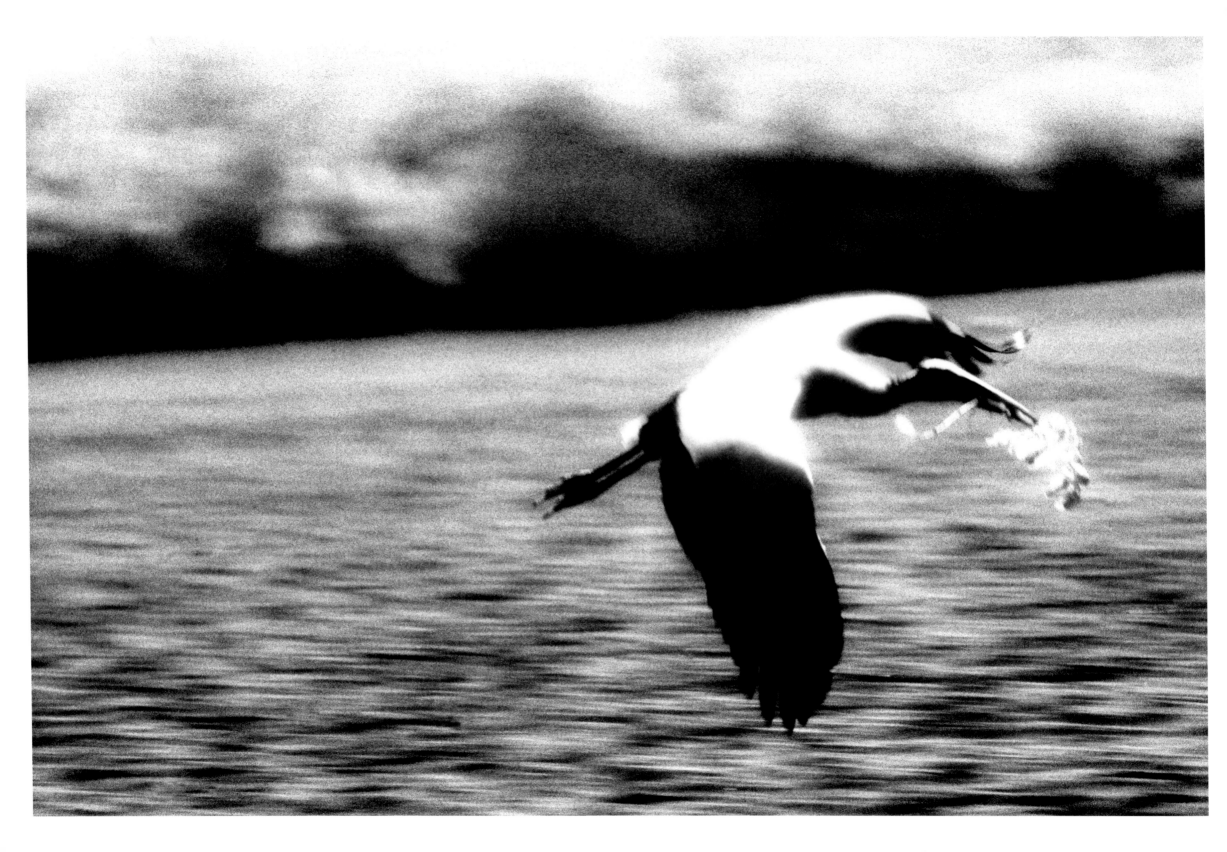

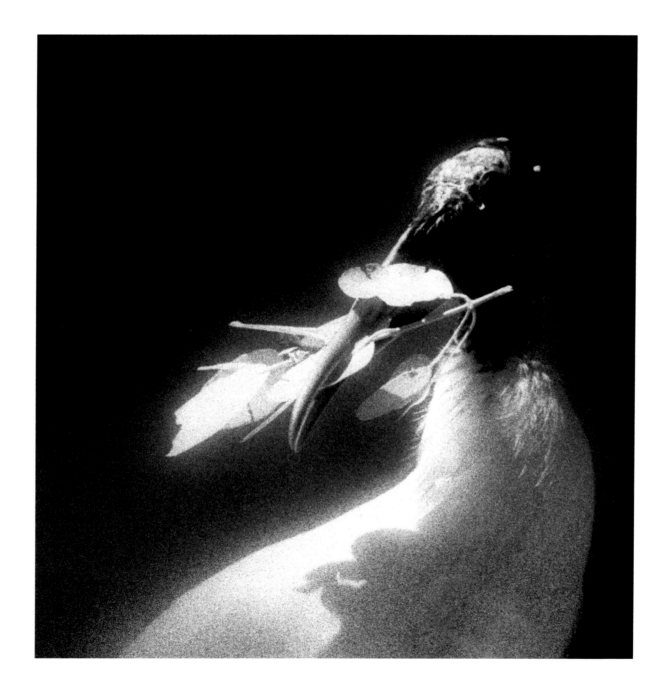

Wood Storks, Myakka River Valley, Sarasota County, Florida, 2005

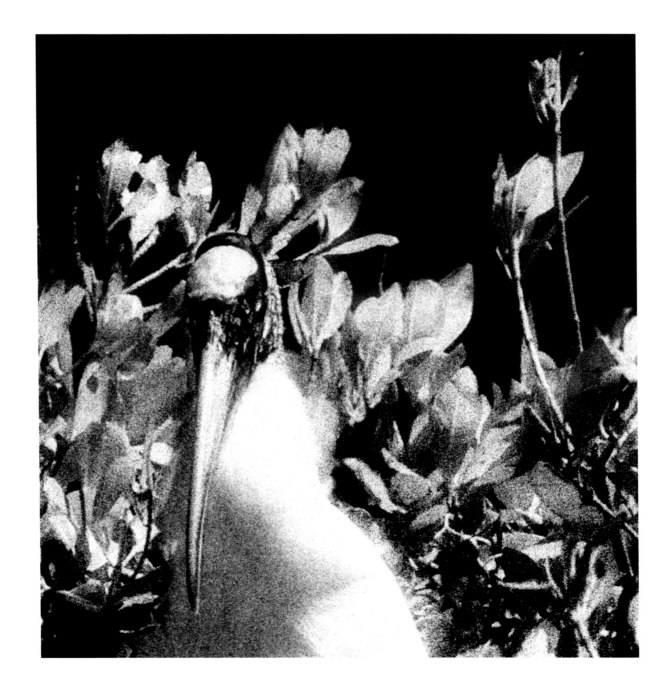

Wood Storks and Great Egret, Myakka River Valley, Sarasota County, Florida, 2005

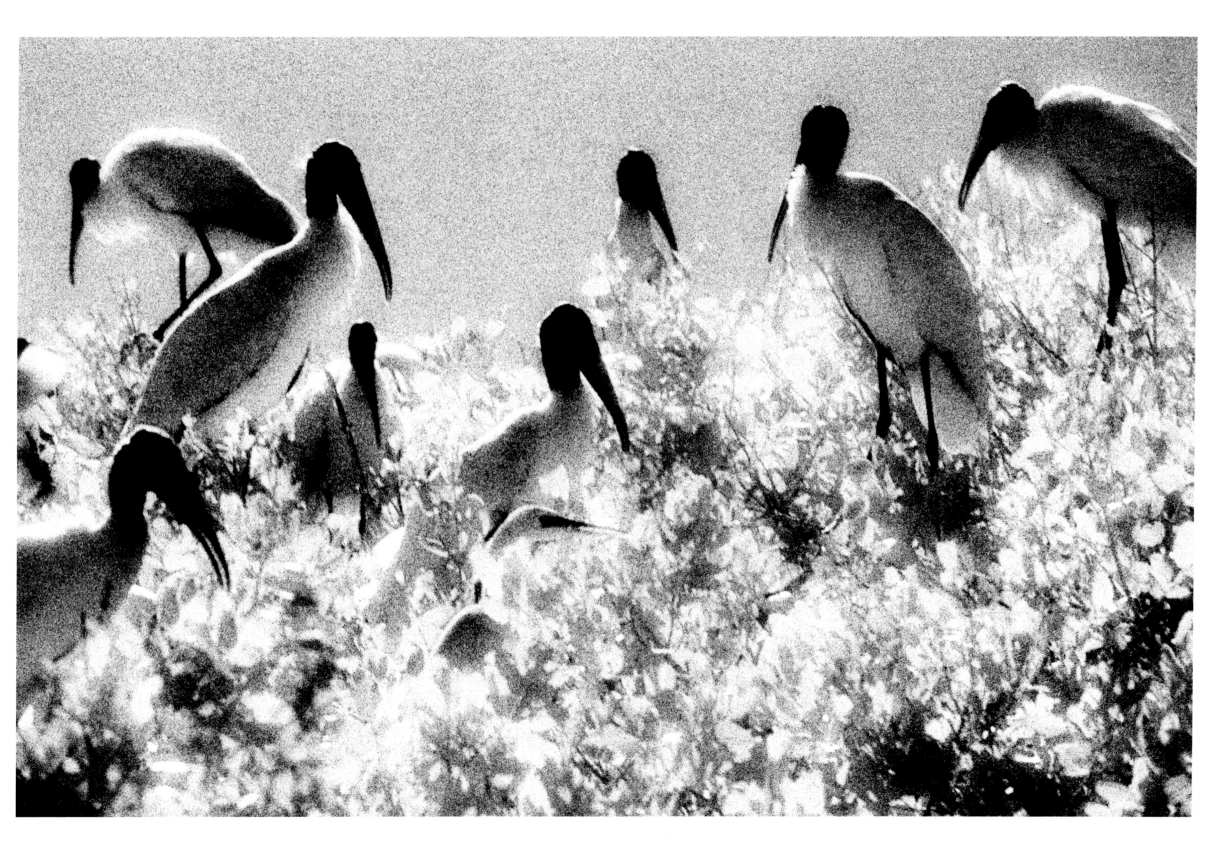

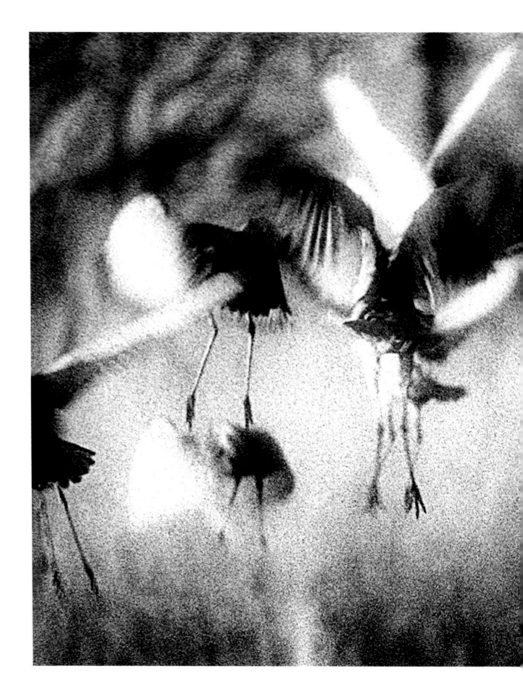

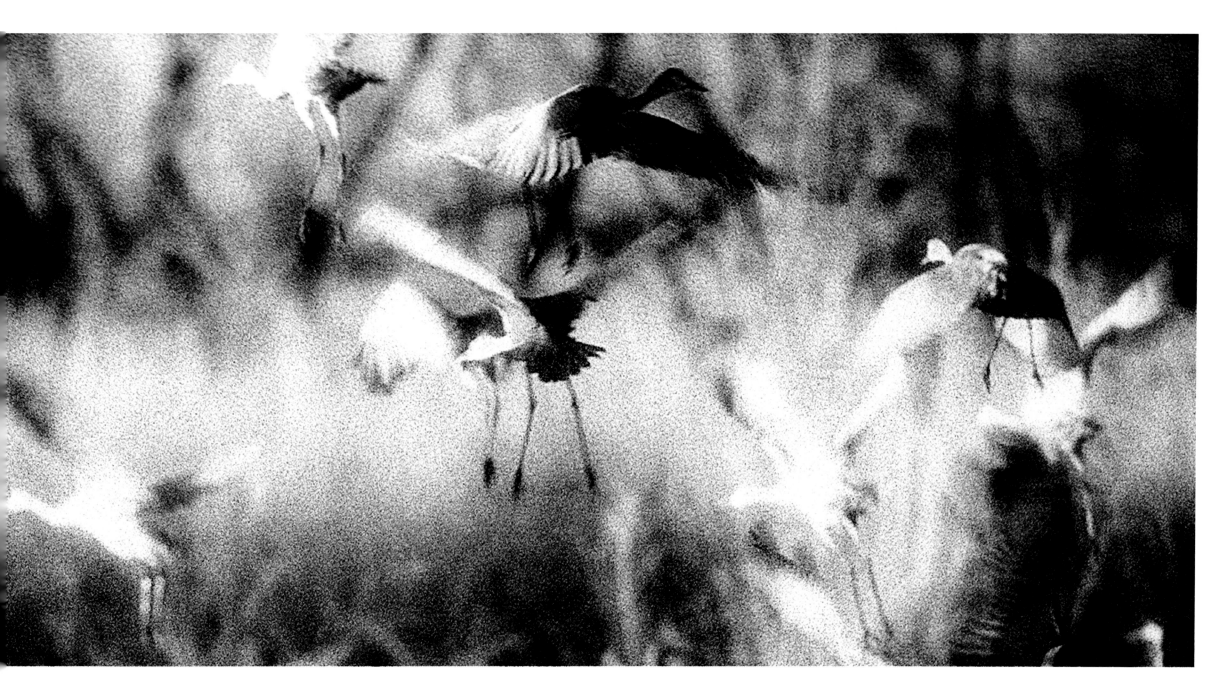

Sandhill Cranes, Platte River Valley near Grand Island, Nebraska, 2003

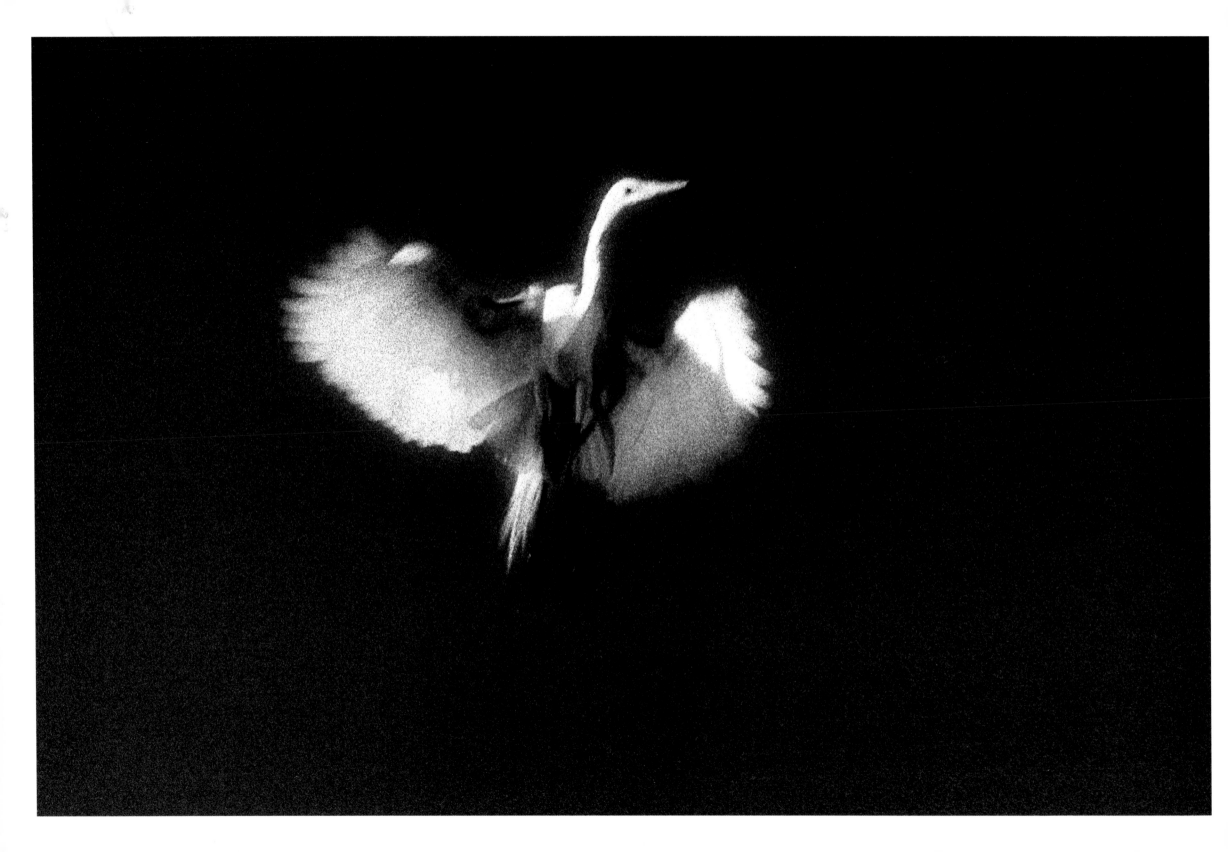

I'd rather learn from one bird how to sing than to teach ten thousand stars how not to dance.

— e.e. cummings

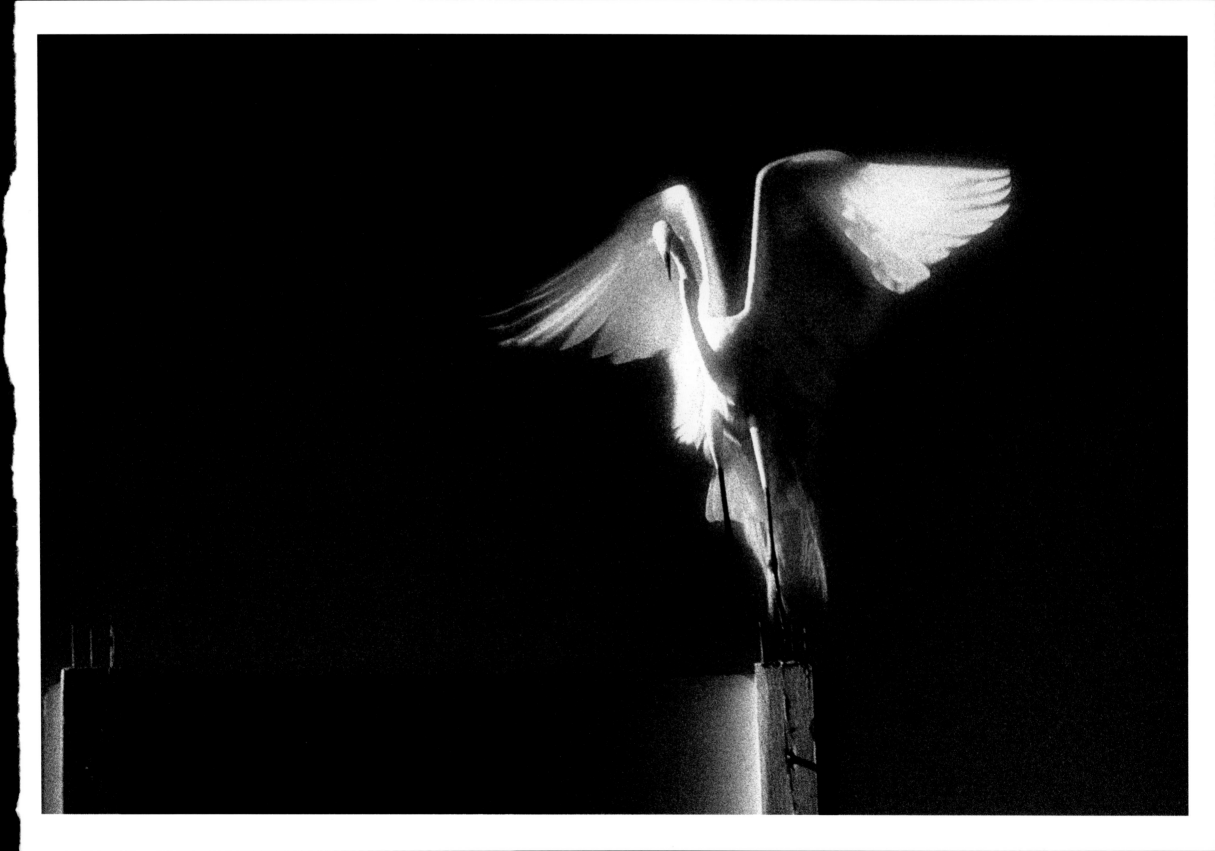

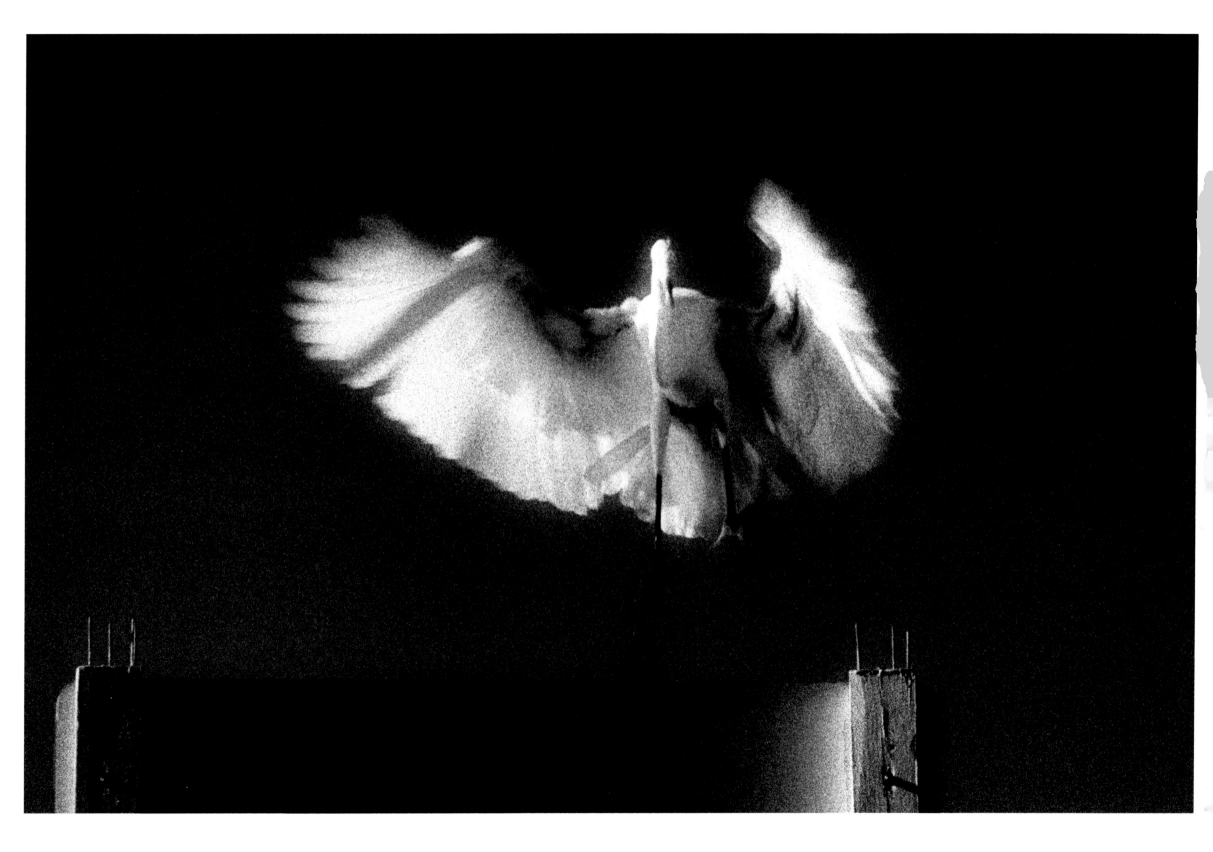

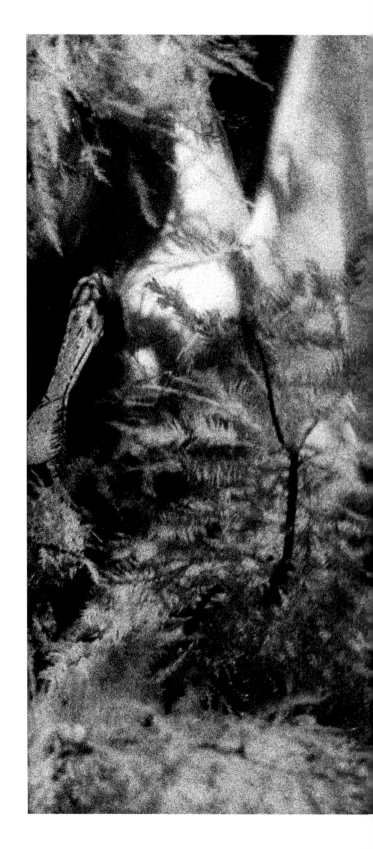

Roseate Spoonbills, Lake Martin, Breaux Bridge, Louisiana, 2004

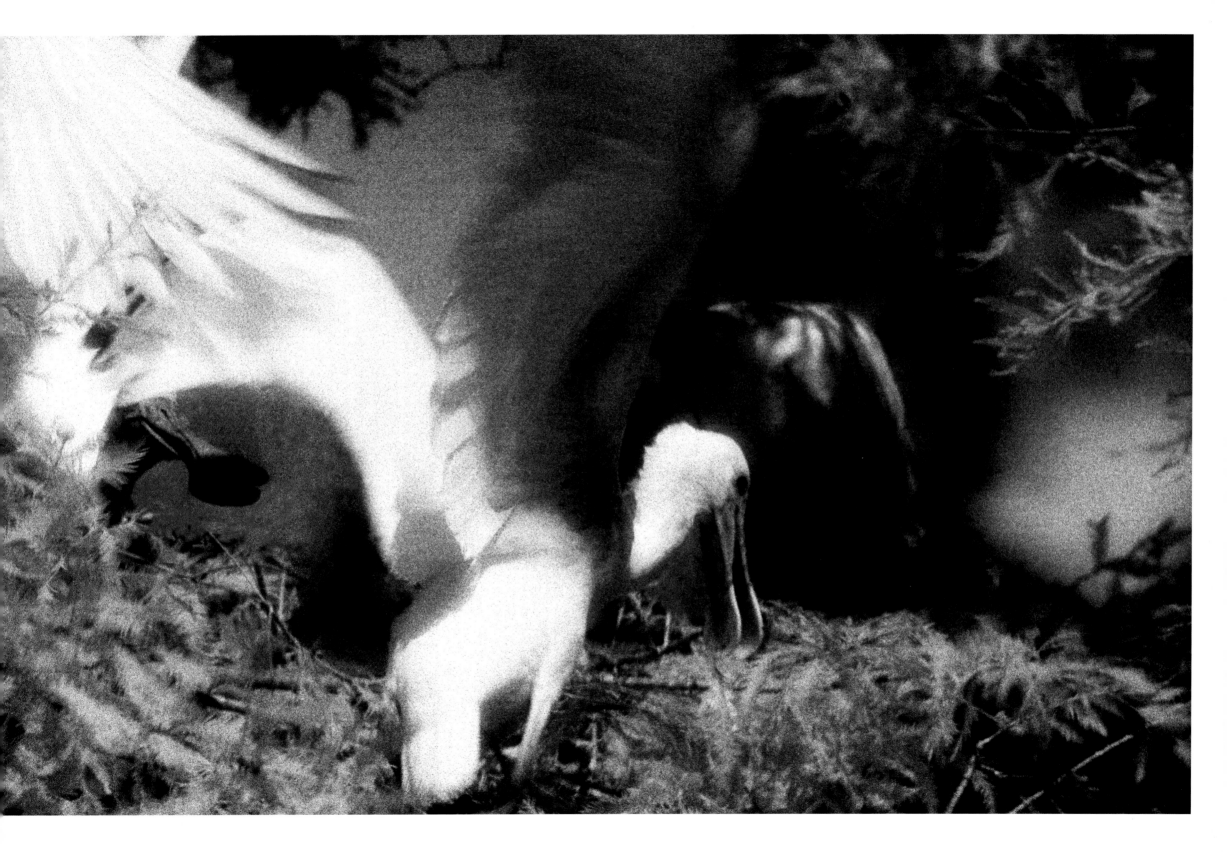

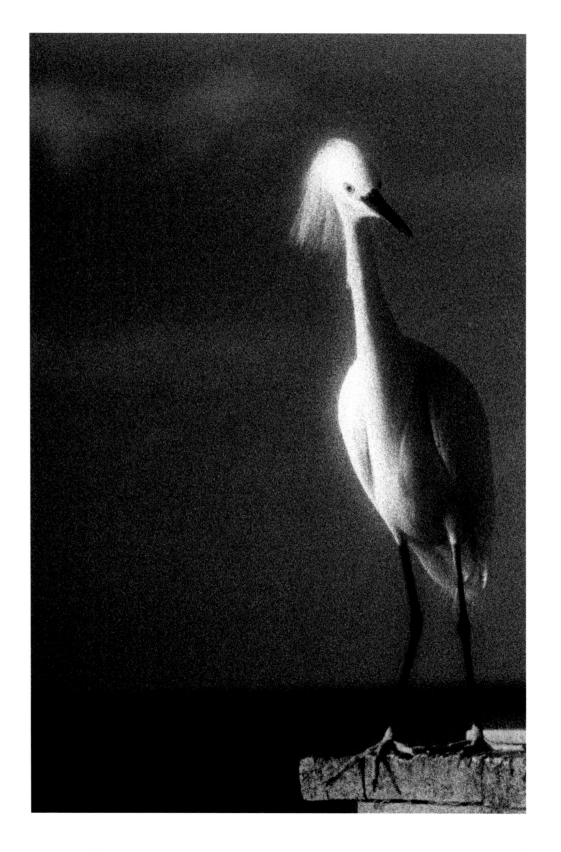

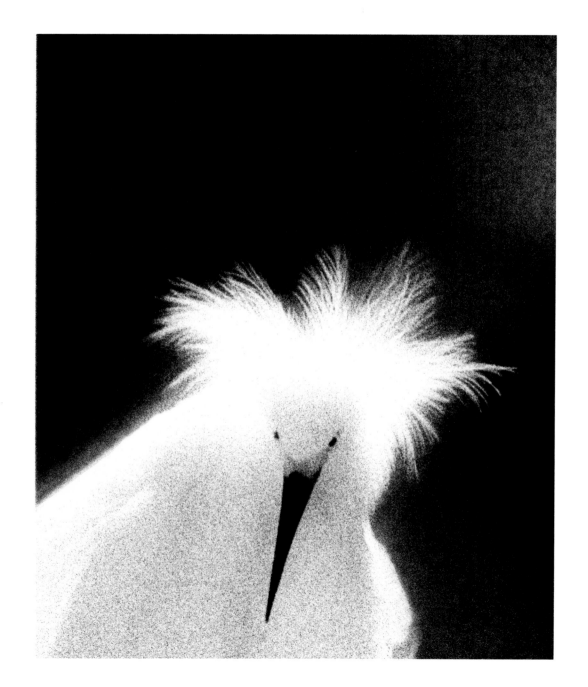

OPPOSITE: Snowy Egret, Anna Maria Island, Florida, 1999 ABOVE: Snowy Egret, Lake Martin, Breaux Bridge, Louisiana, 2004.

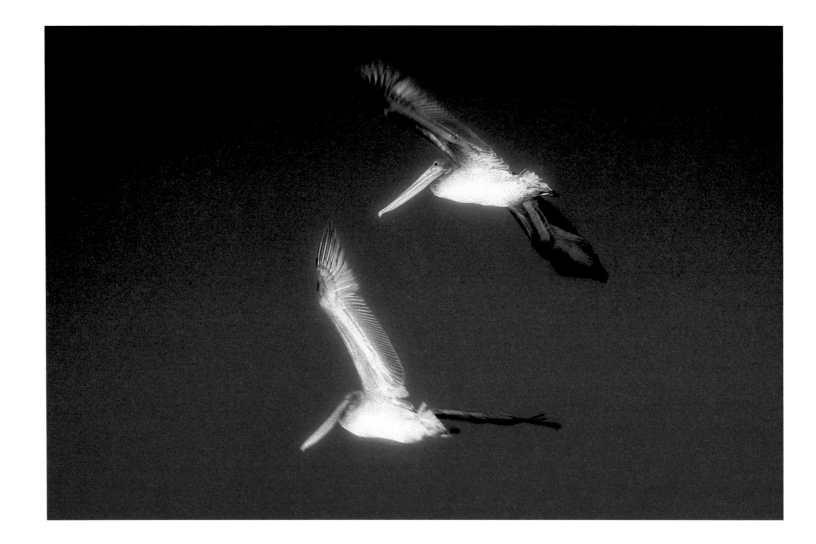

ABOVE: Brown Pelicans, Abbotts Lagoon, Point Reyes Peninsula, California 2004 OPPOSITE: Brown Pelican, Siesta Key, Sarasota, Florida, 1998

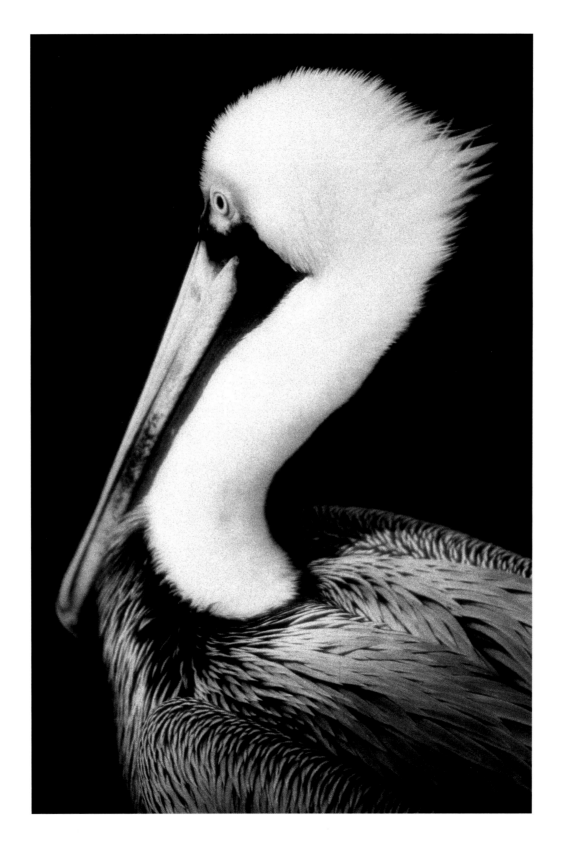

Pelicans seem always to know exactly where they are going.

— john steinbeck

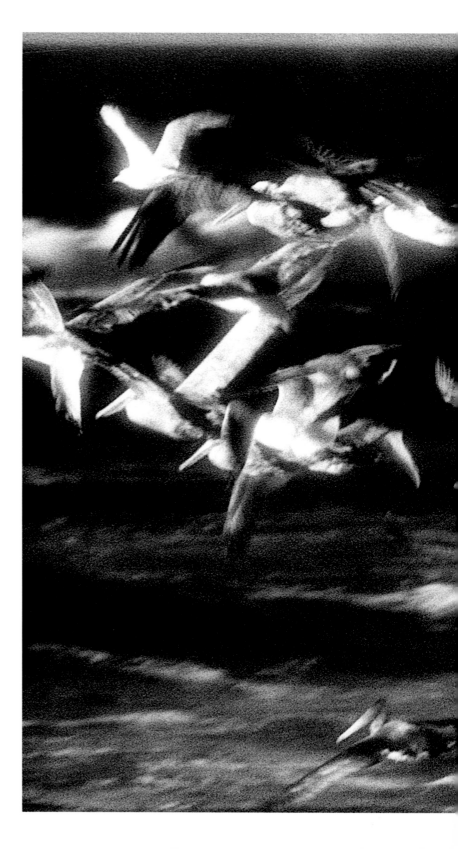

Brown Pelicans and Gulls, Pacific Ocean, Point Reyes Peninsula, California, 2004

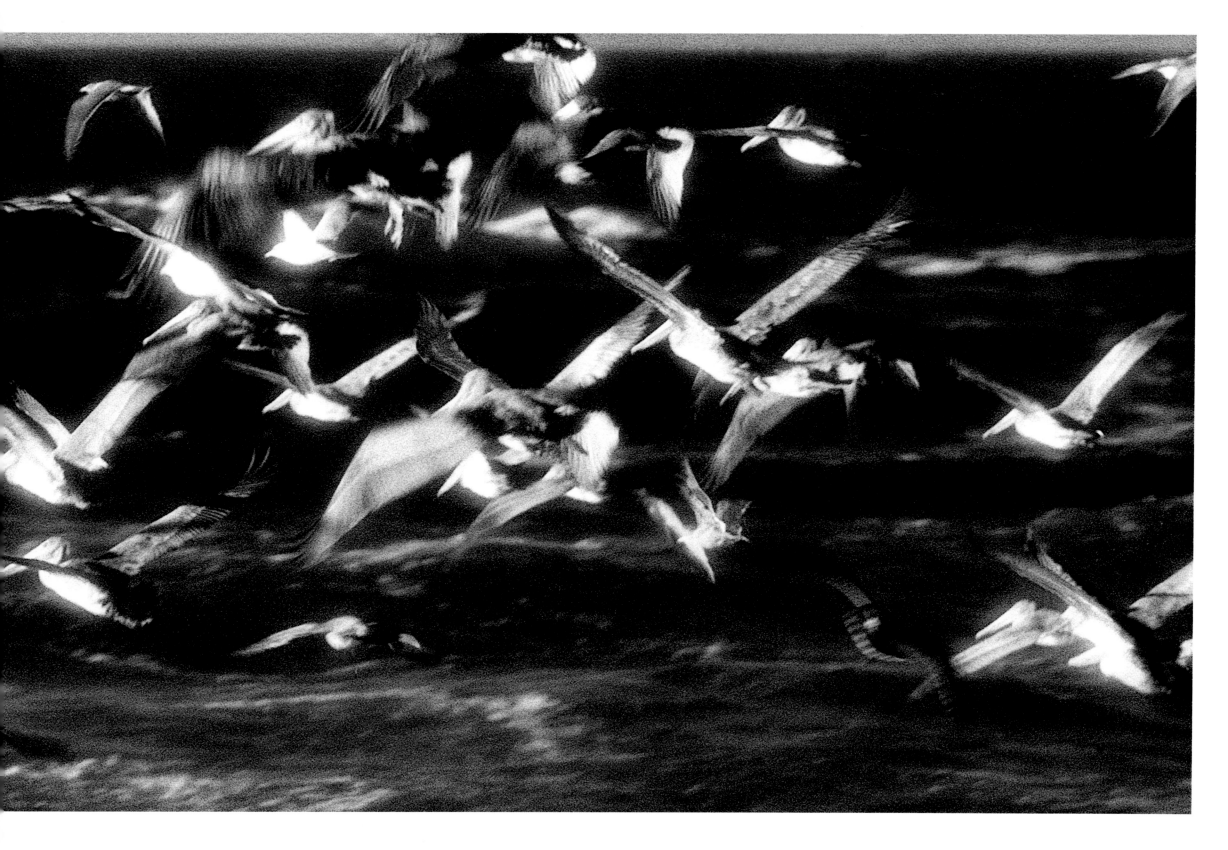

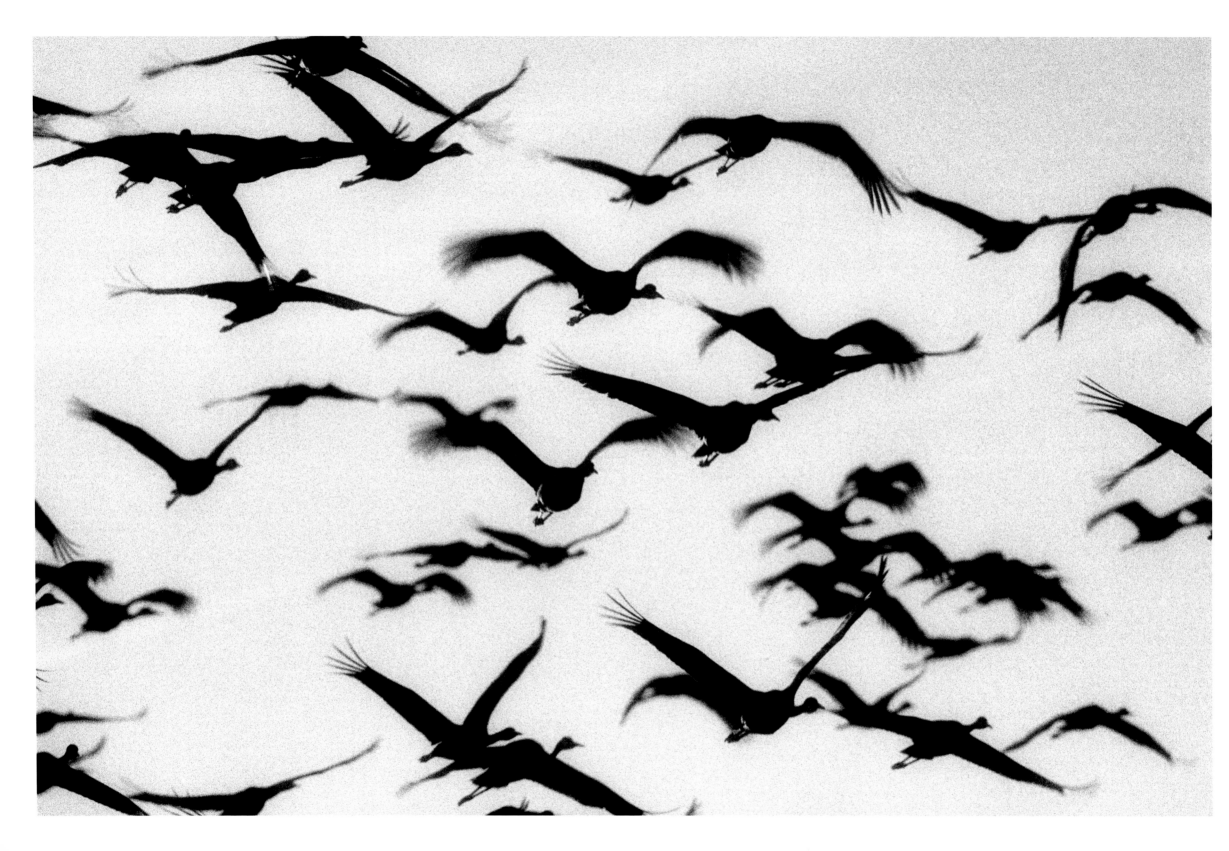

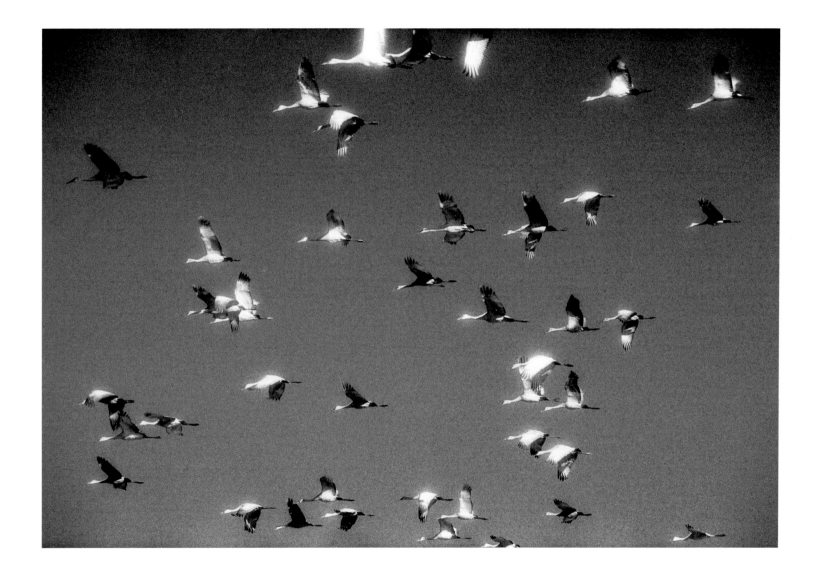

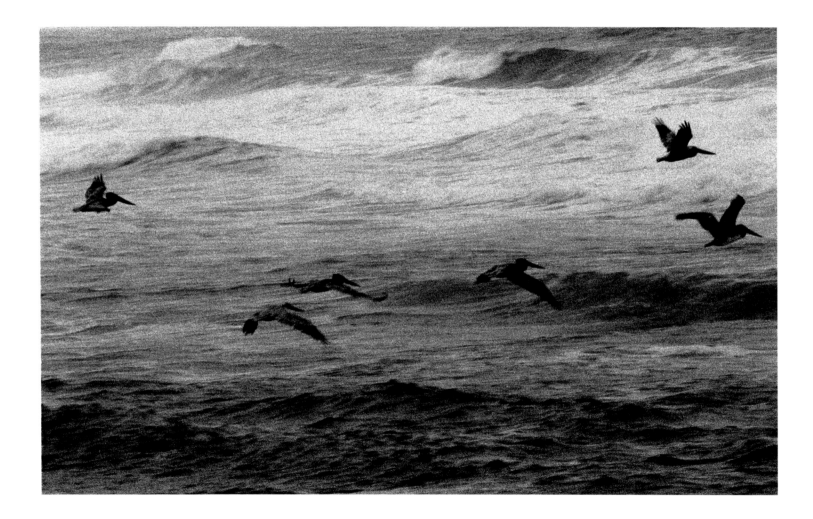

ABOVE: Brown Pelicans, Pacific Ocean, Point Reyes Peninsula, California, 2004 OPPOSITE: White Pelicans, Pacific Ocean, Point Reyes Peninsula, California, 2005

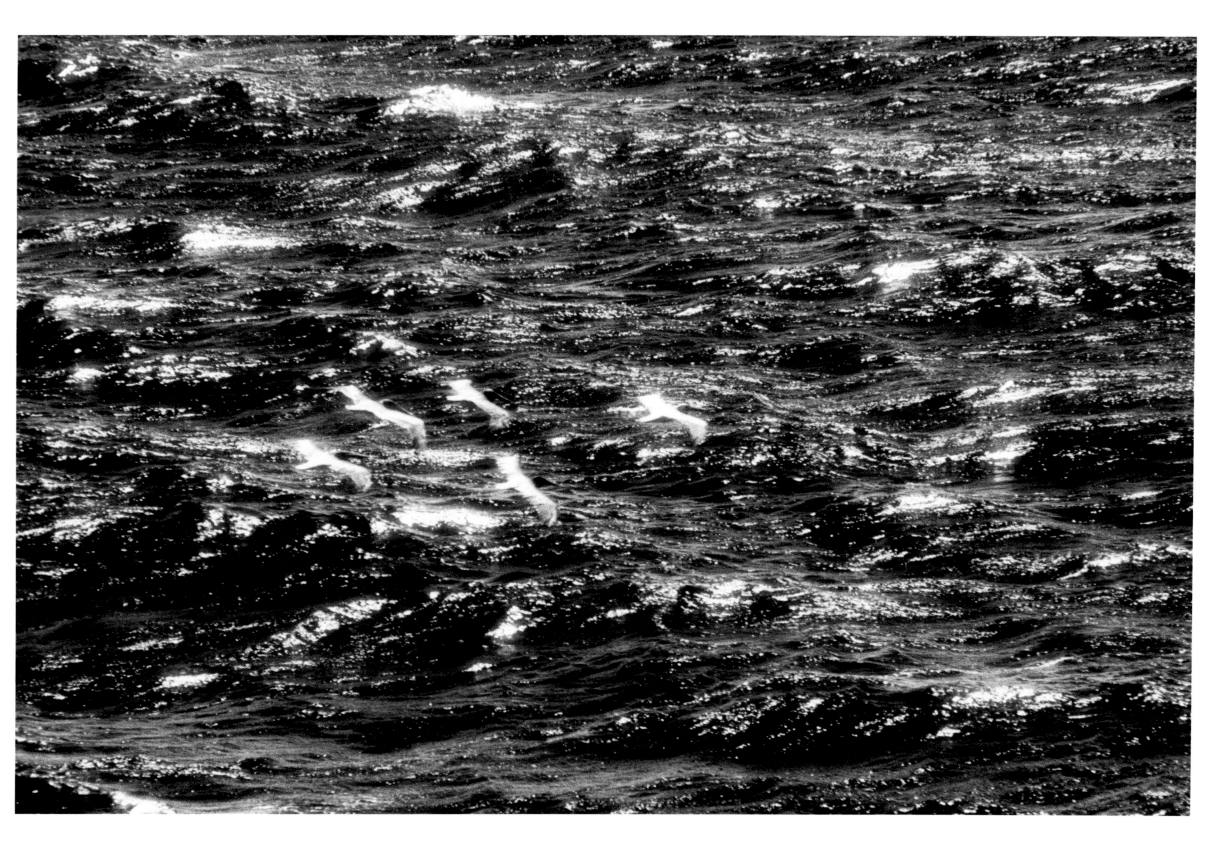

I realized that if I had to choose, I would rather have birds than airplanes.

— charles lindberg

Tundra Swans, Bear River, Box Elder County, Utah, 2006

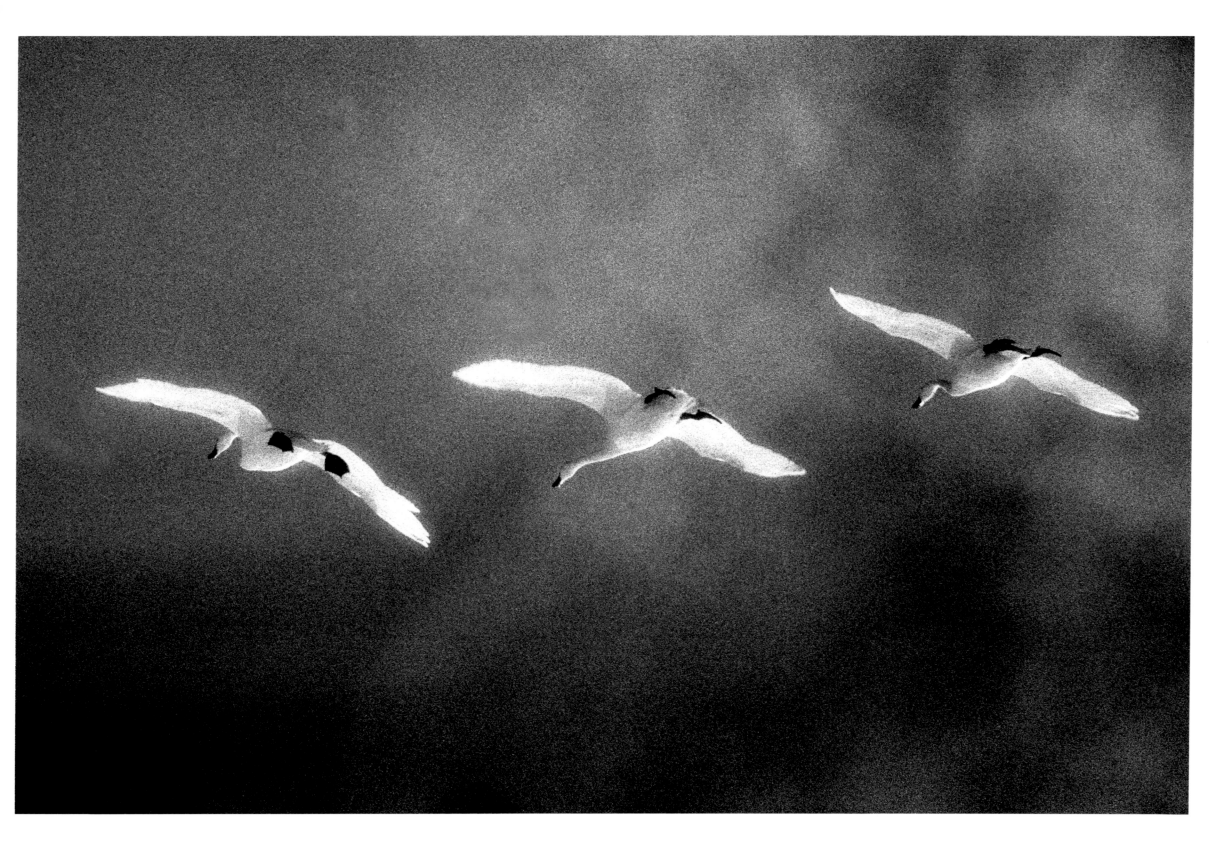

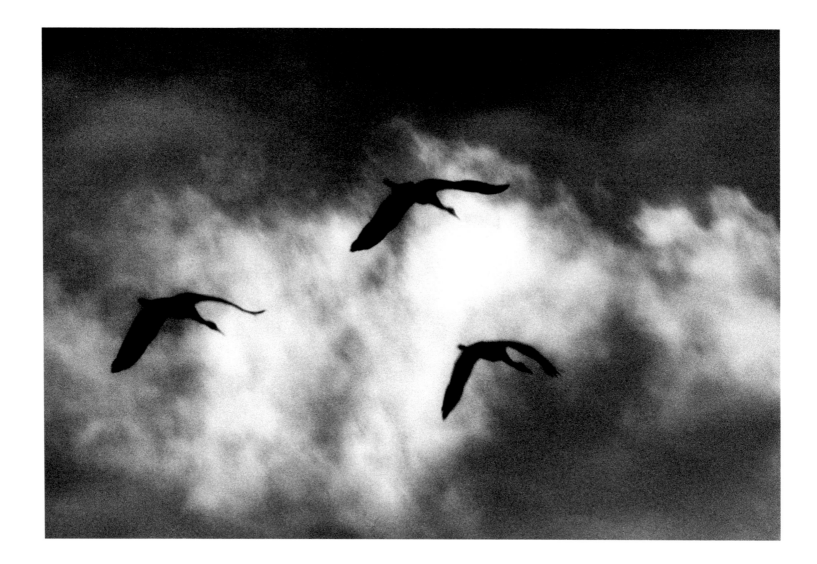

ABOVE: Sandhill Cranes, Baraboo, Wisconsin, 2000 OPPOSITE: Sandhill Cranes, Baraboo, Wisconsin, 2000

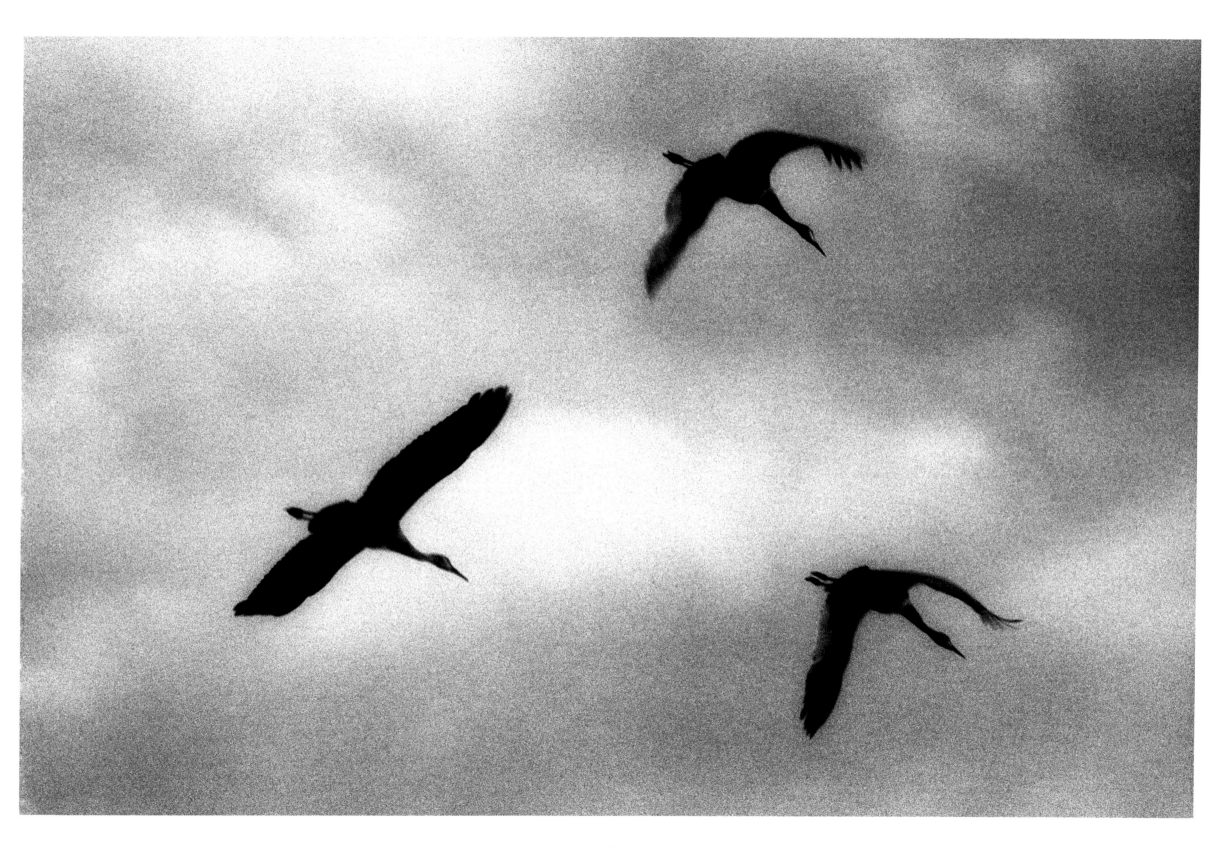

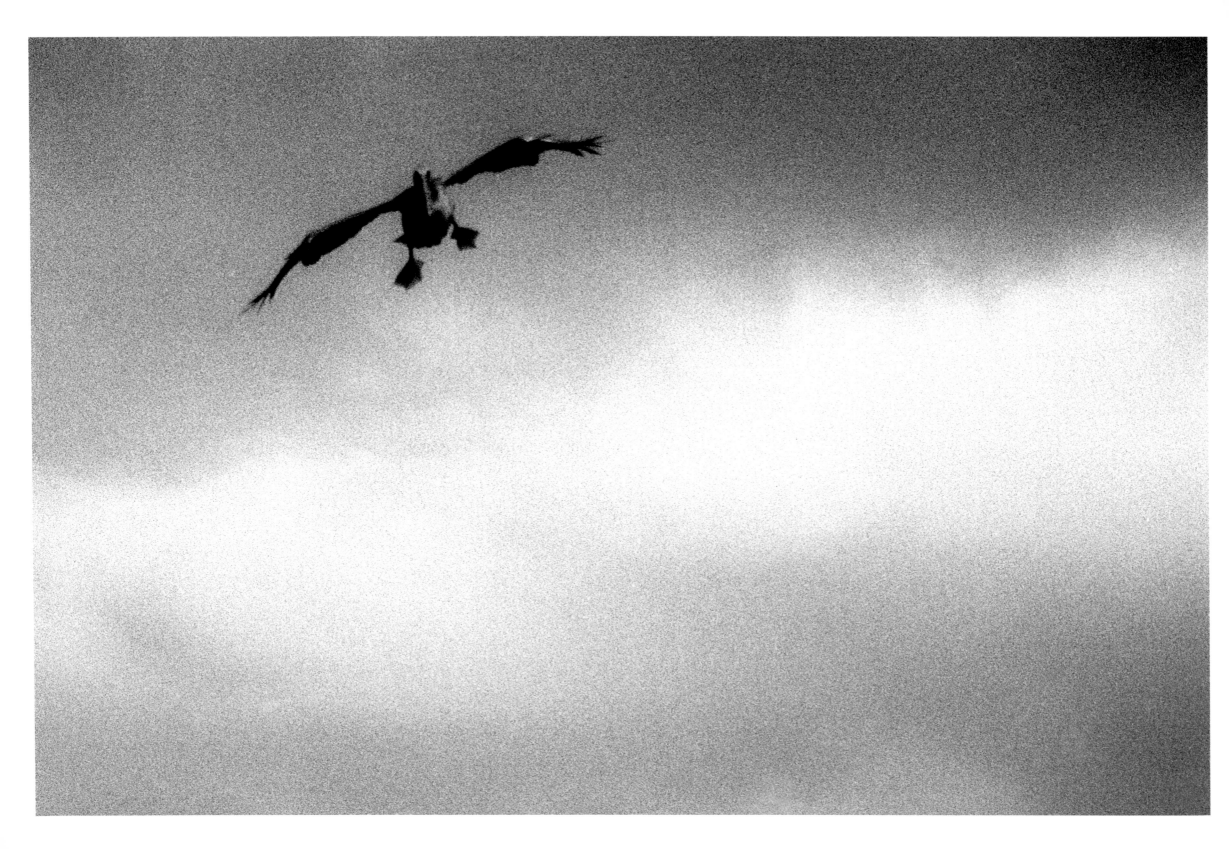

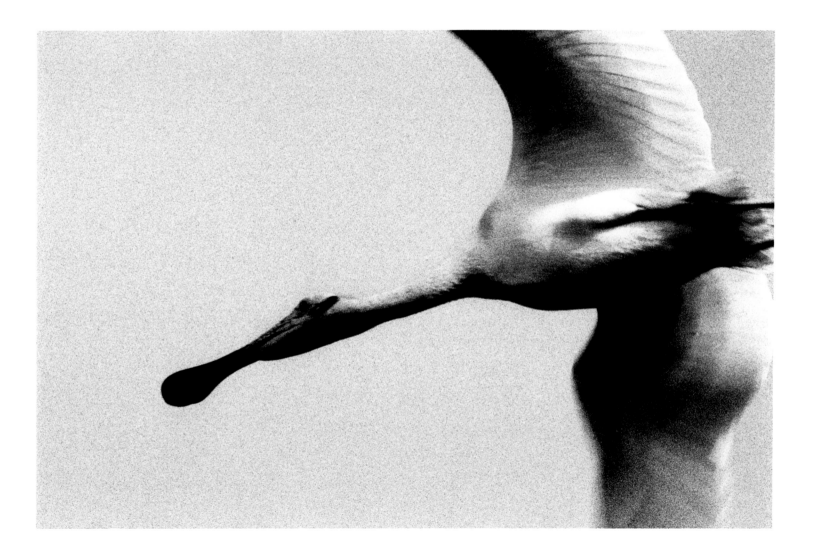

OPPOSITE: Brown Pelican landing, Sarasota Bay, Sarasota, Florida, 2001 ABOVE: Roseate Spoonbill, Lake Martin, Breaux Bridge, Louisiana, 2004

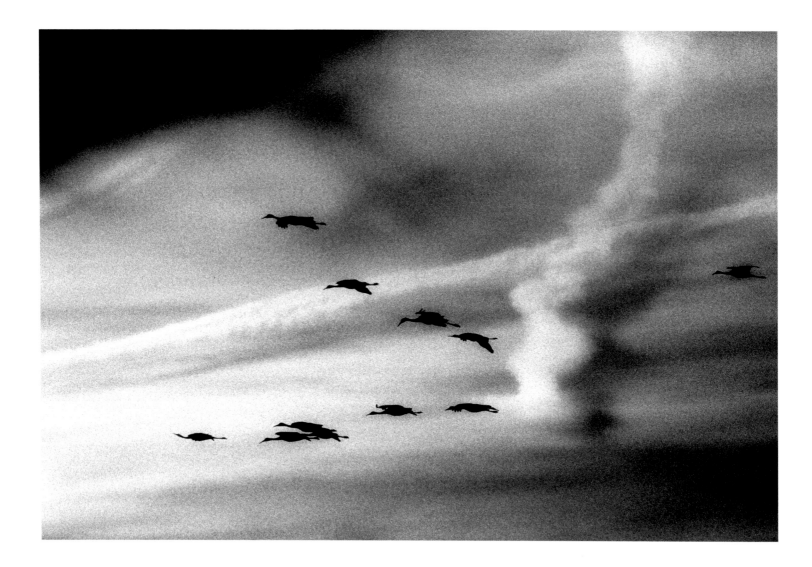

ABOVE: Sandhill Cranes, the Platte River Valley near Grand Island, Nebraska, 2004 OPPOSITE: Great Egret, St. Petersburg, Florida, 2002

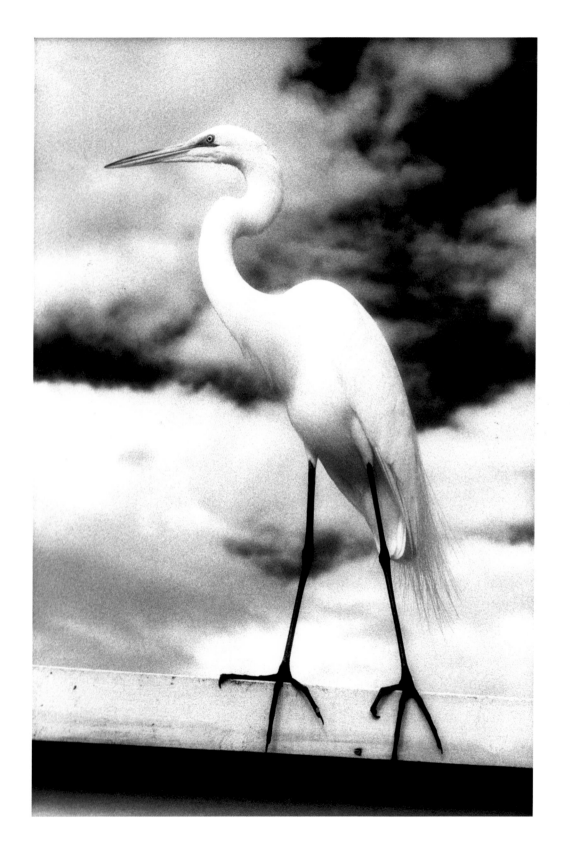

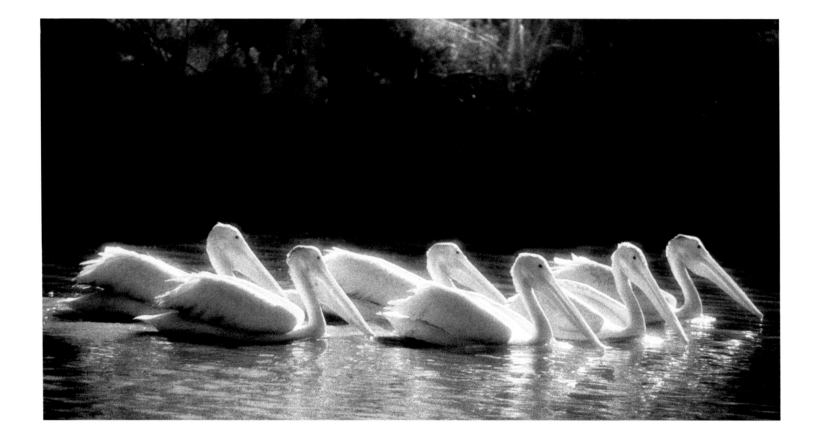

ABOVE: White Pelicans, Bear River Migratory Bird Refuge, Box Elder County, Utah, 2002 OPPOSITE: White Pelicans, Bear River Migratory Bird Refuge, Box Elder County, Utah, 2003

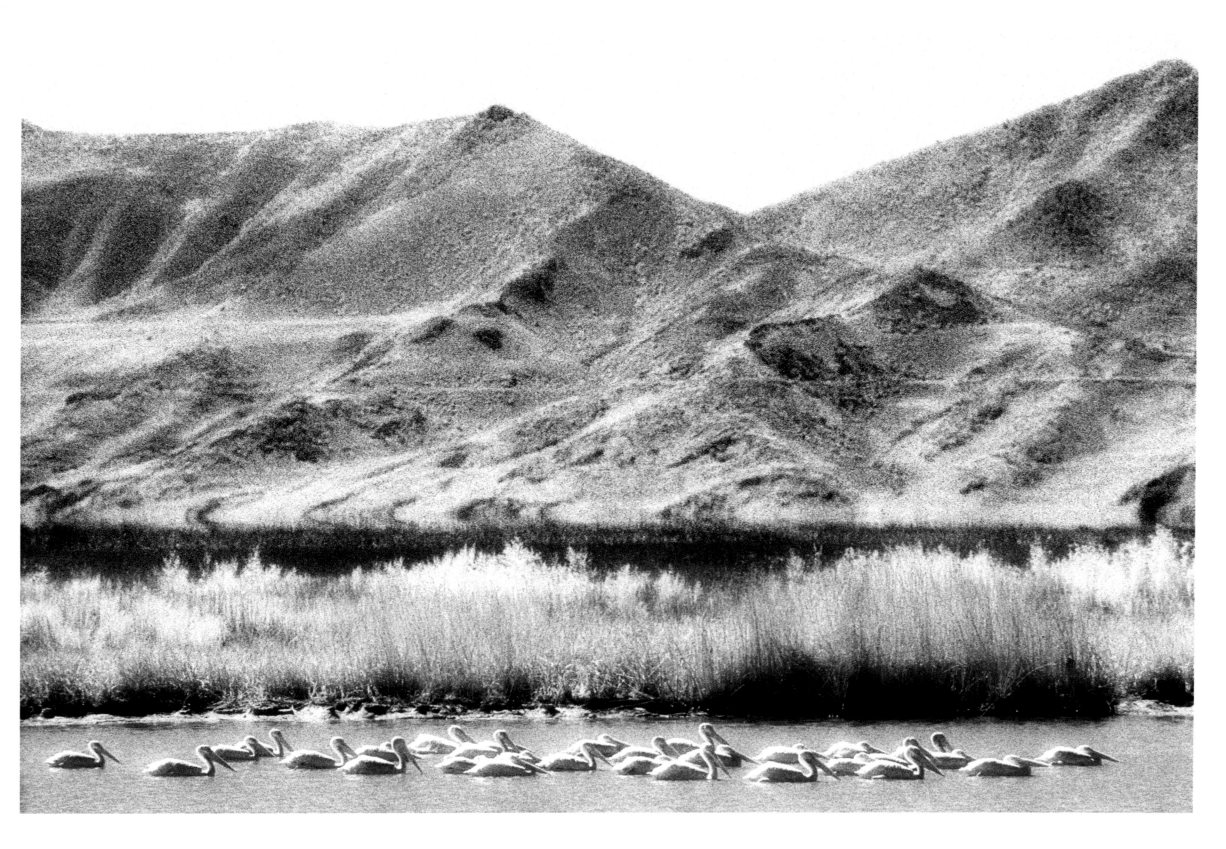

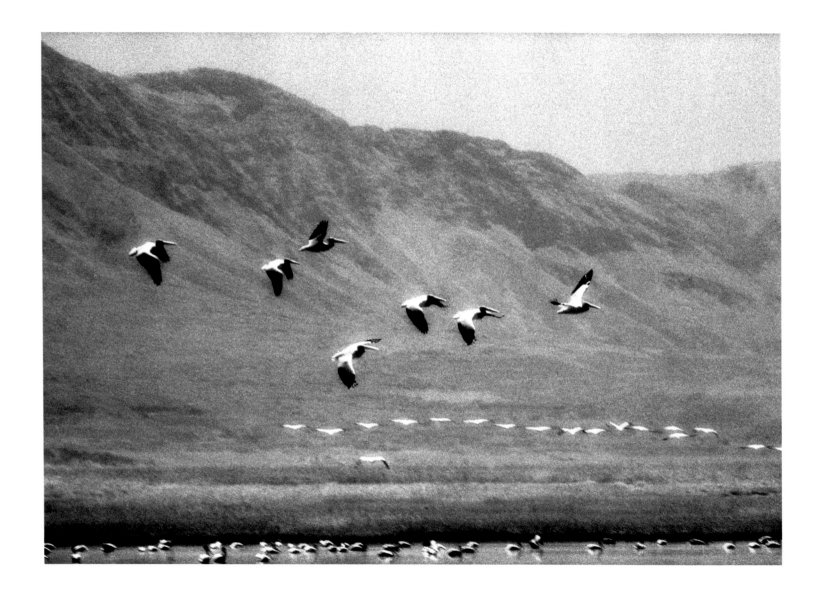

ABOVE: White Pelicans, Bear River Migratory Bird Refuge, Box Elder County, Utah, 2005 OPPOSITE: White Pelicans, Bear River Migratory Bird Refuge, Box Elder County, Utah, 2002

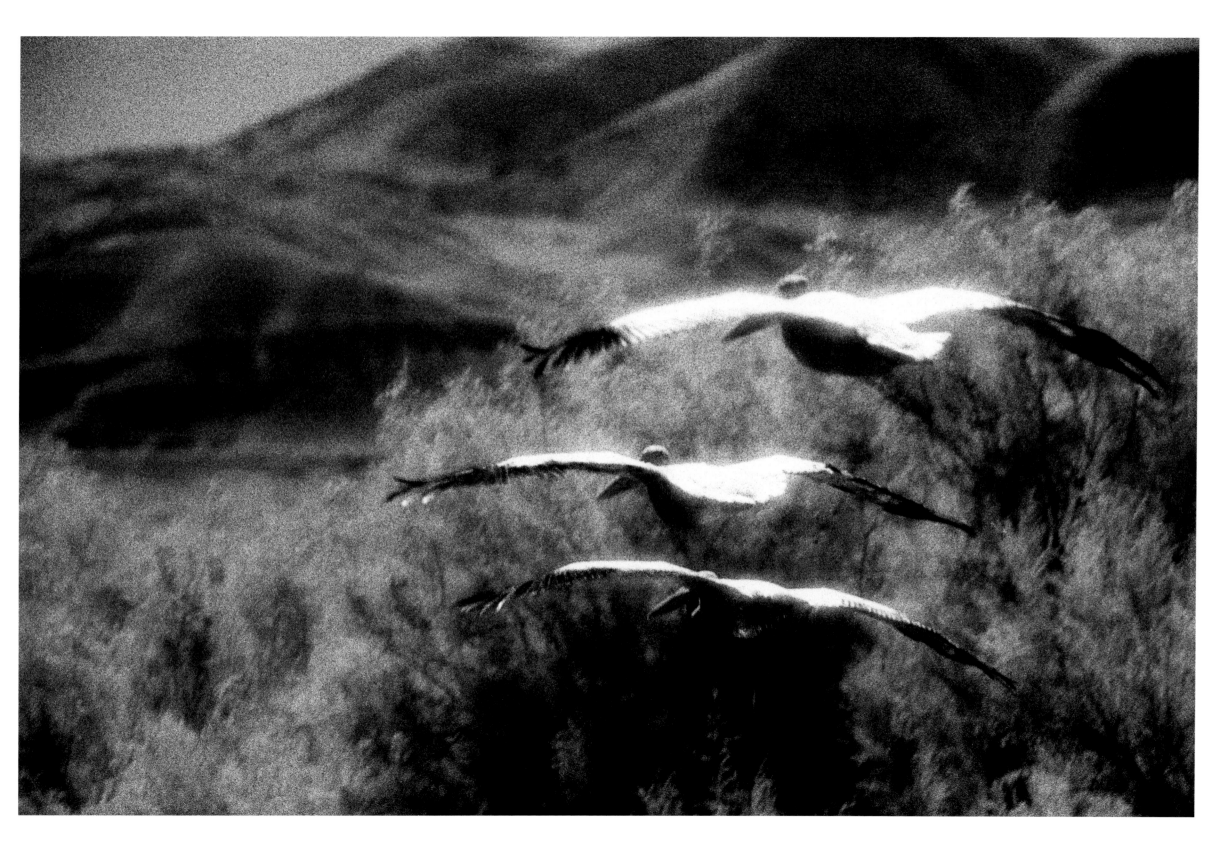

The birds have vanished down the sky.
Now the last cloud drains away.
We sit together, the mountain and me,
until only the mountain remains.

— li po (rihaku)

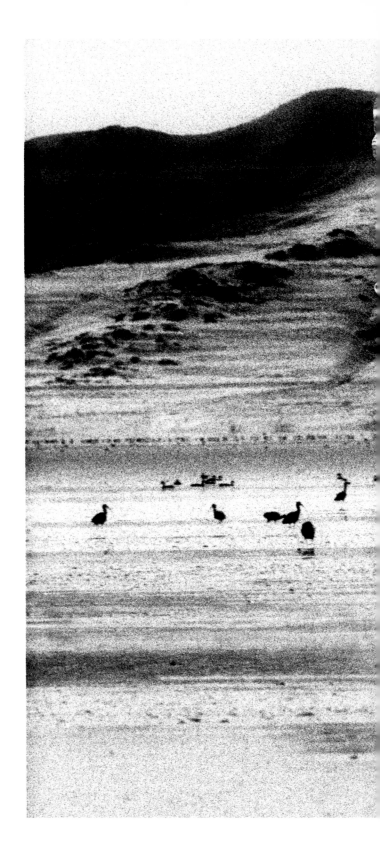

White-faced Ibises, Farmington Bay, Great Salt Lake, Utah, 2005

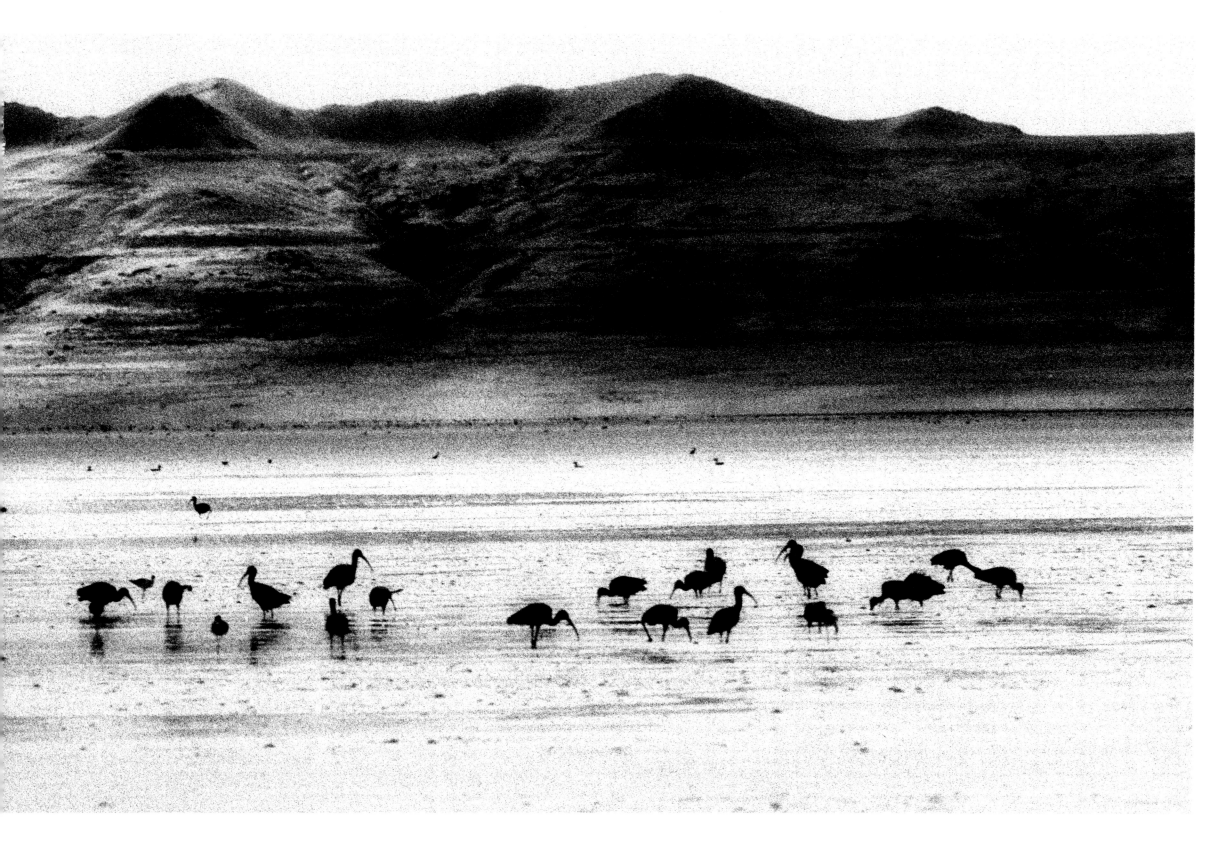

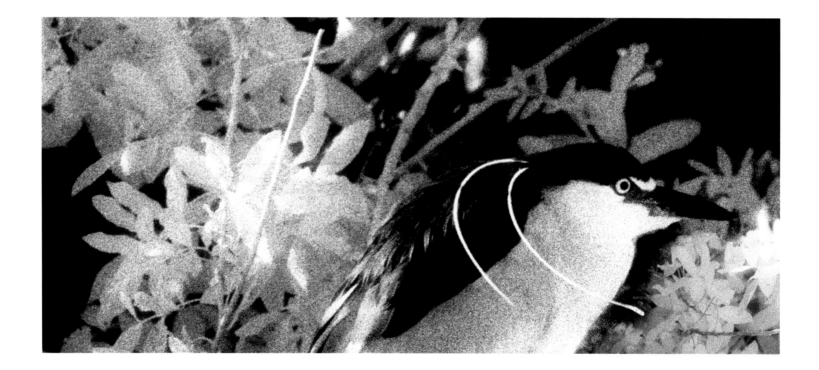

ABOVE: Black-crowned Night Heron, Venice Rookery, Venice, Florida, 2005 OPPOSITE: Great Blue Heron, Brooklyn Botanic Garden, Brooklyn, New York, 2006

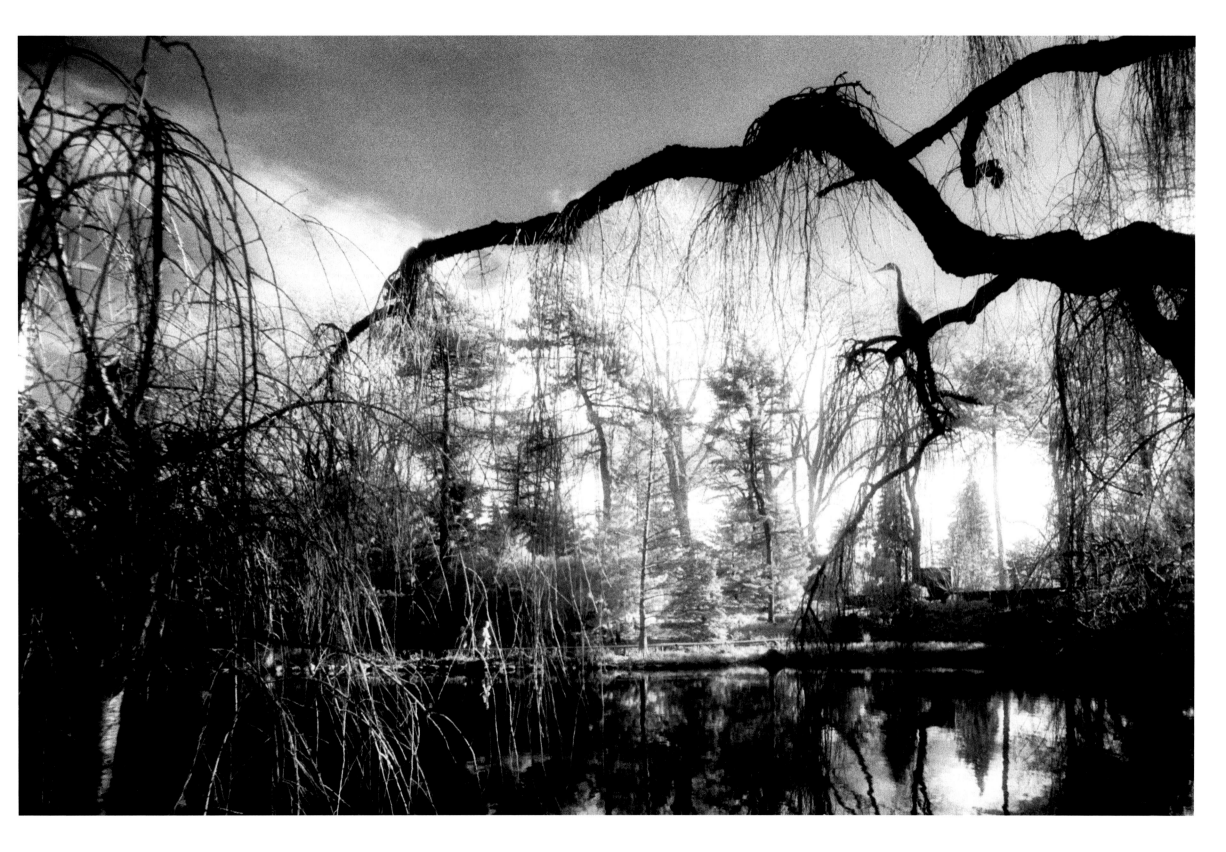

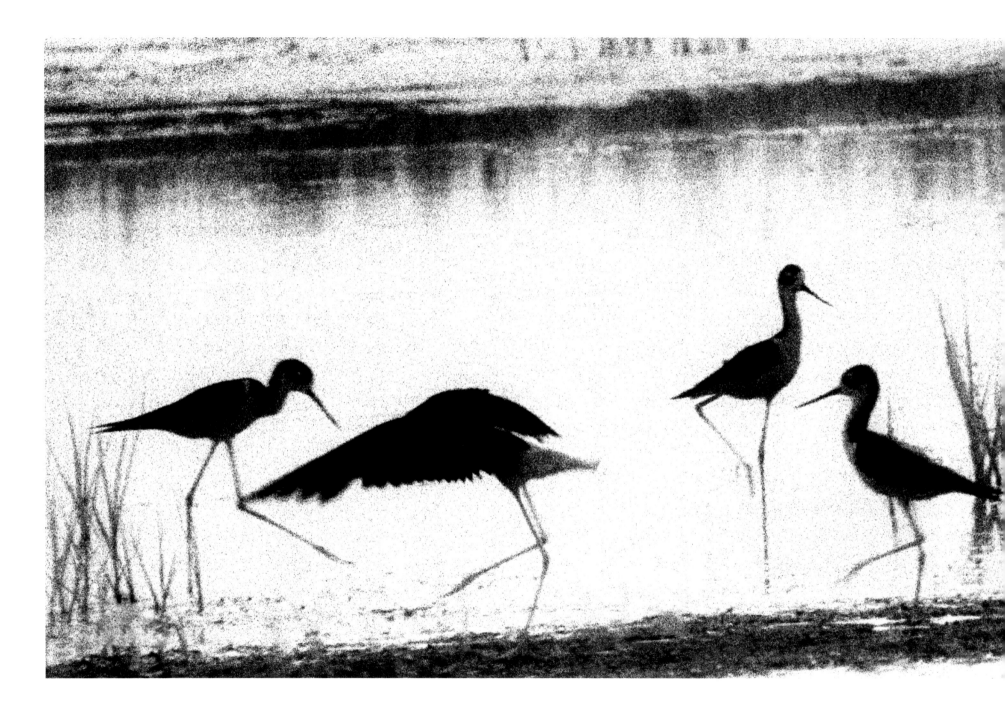

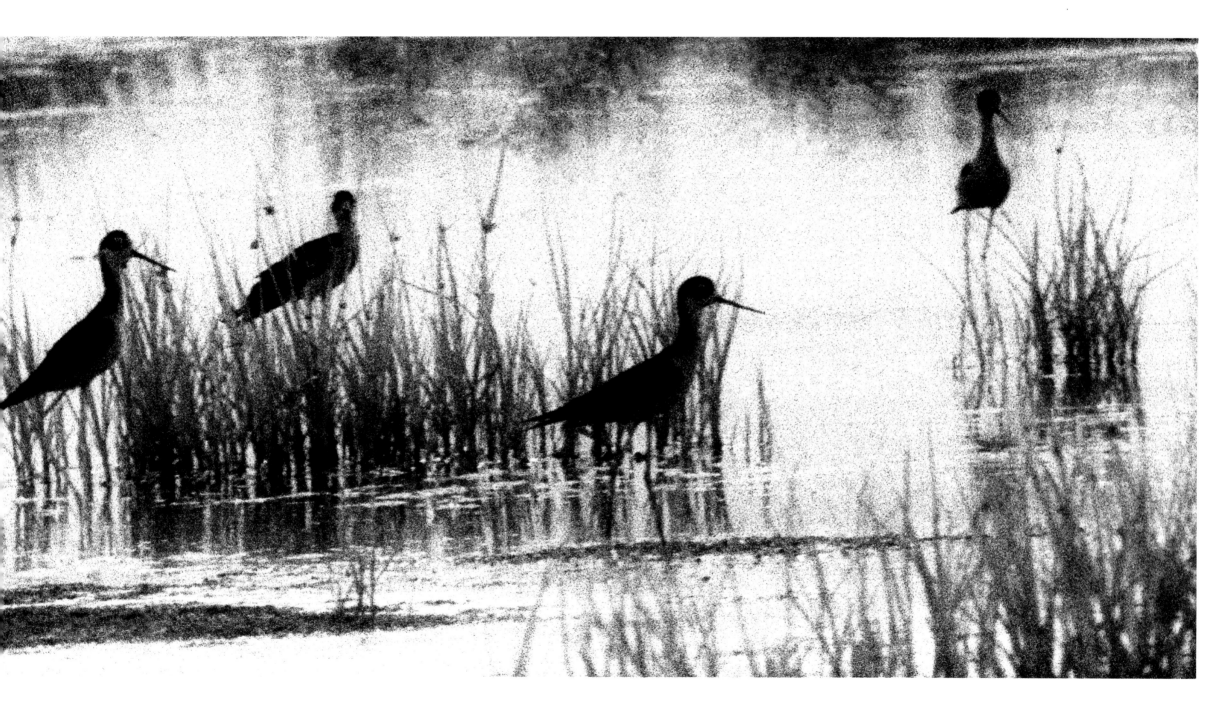

Black-necked Stilts, Farmington Bay, Great Salt Lake, Utah, 2005

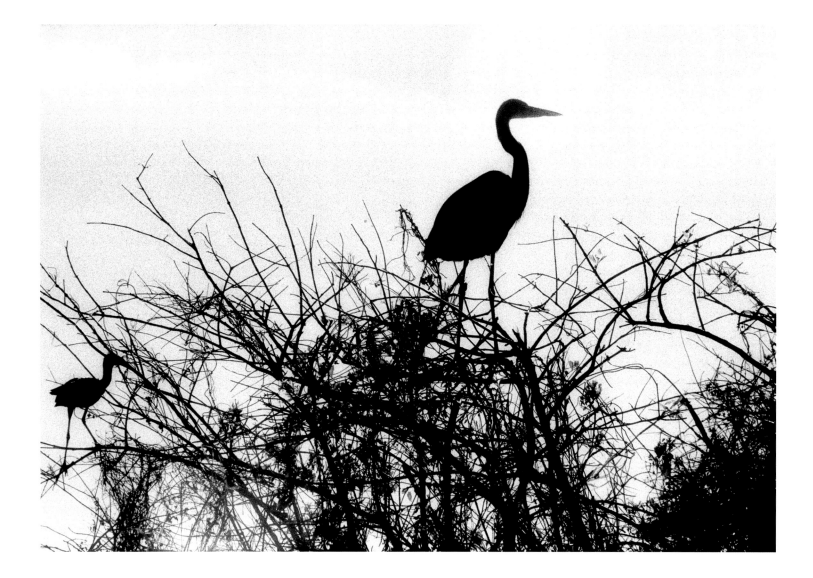

White Ibis & Great Blue Heron, Myakka River Valley, Sarasota County, Florida, 2005

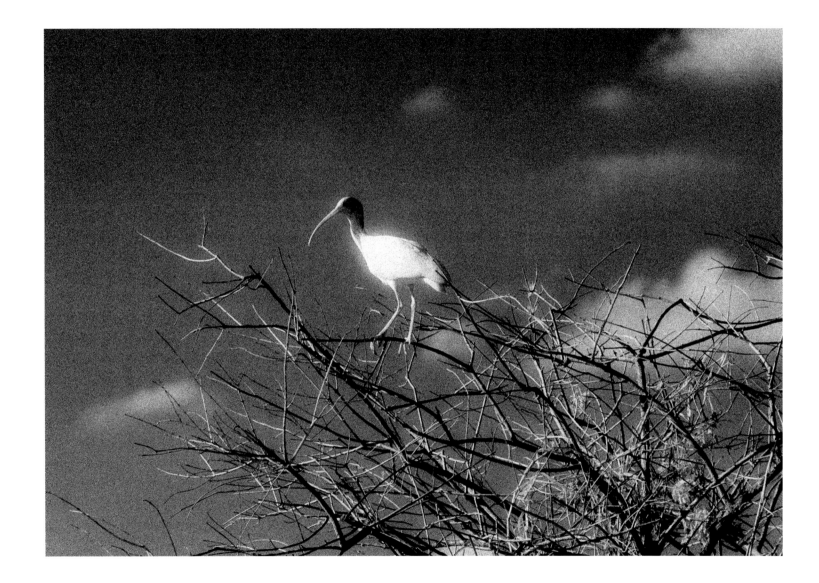

White Ibis, Myakka River Valley, Sarasota County, Florida, 2005

I have read somewhere that the birds of fairyland are white as snow.

— w.b. yeats

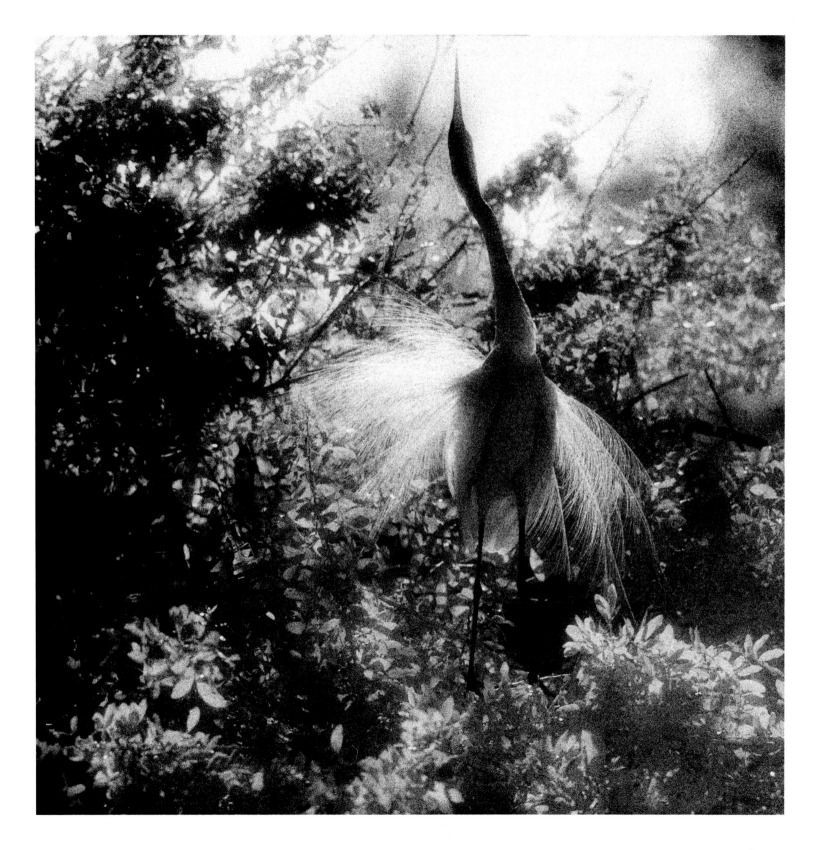

Cypress Stand with Anhingas, Lake Martin, Breaux Bridge, Louisiana, 2004

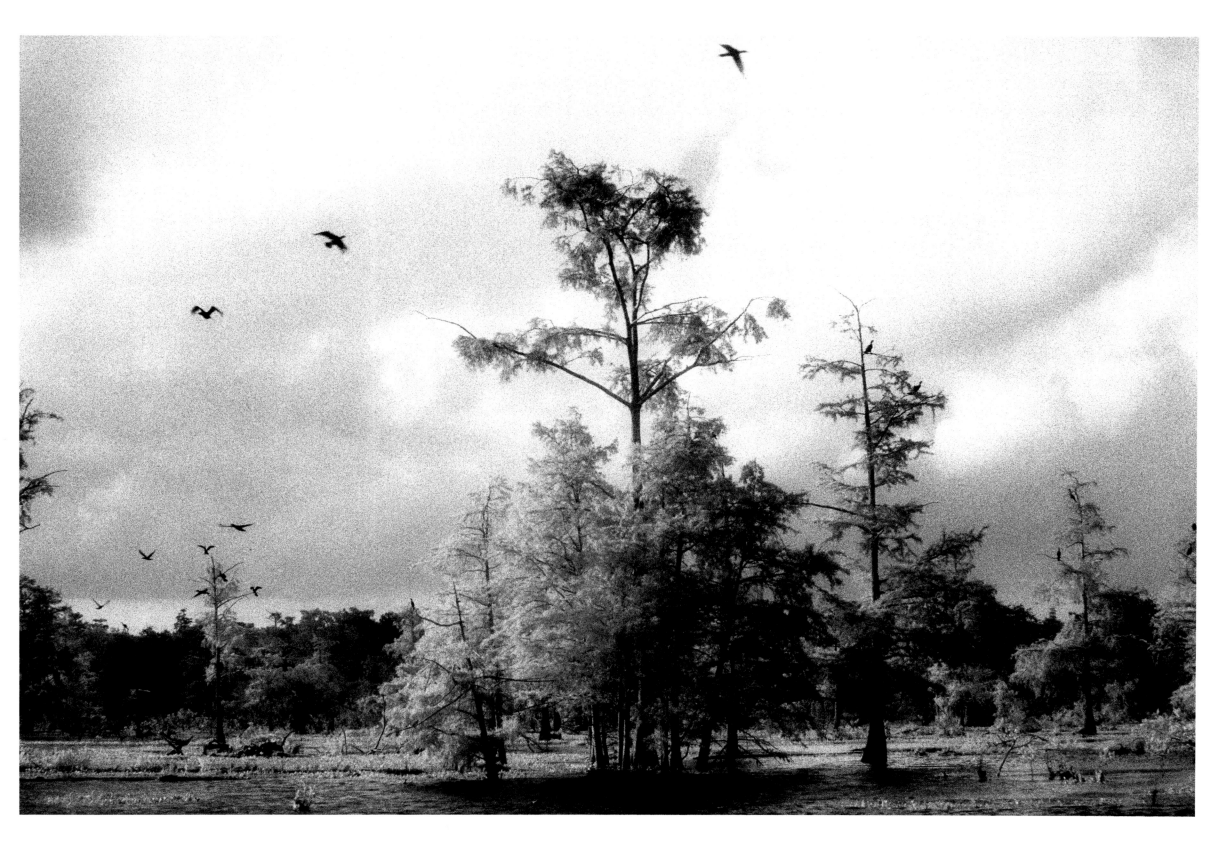

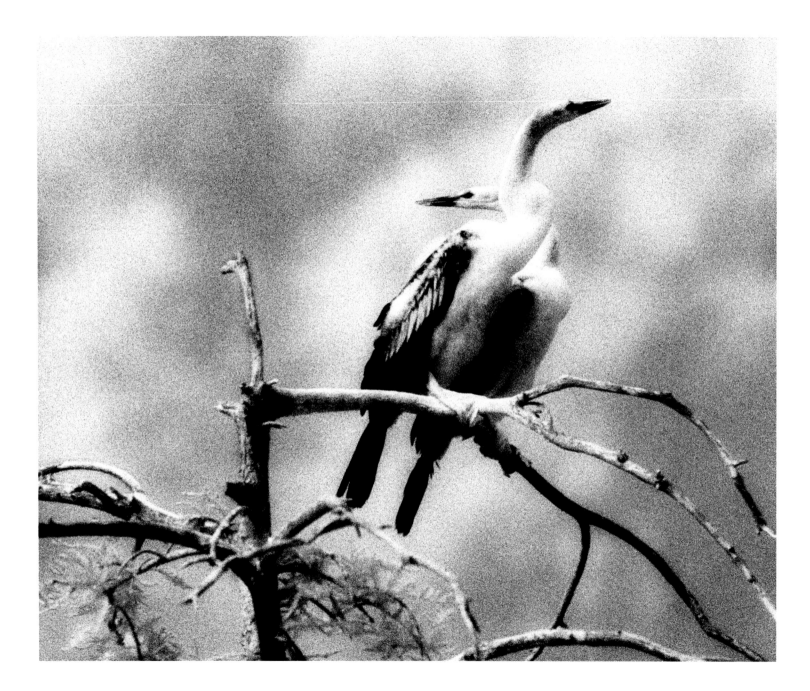

ABOVE: Anhinga chicks, Lake Martin, Breaux Bridge, Louisiana, 2004 OPPOSITE: Double-crested Cormorants, Ogden Bay, Great Salt Lake, Utah, 2003

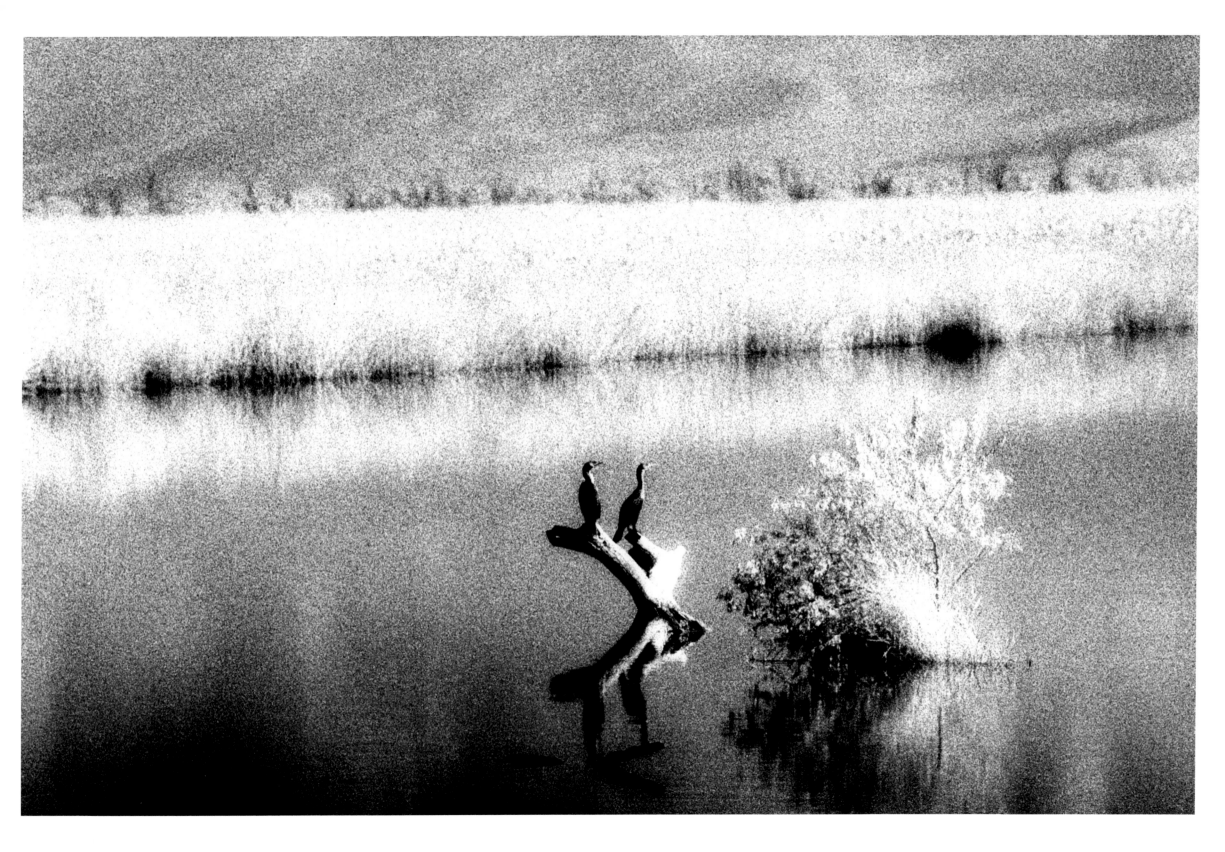

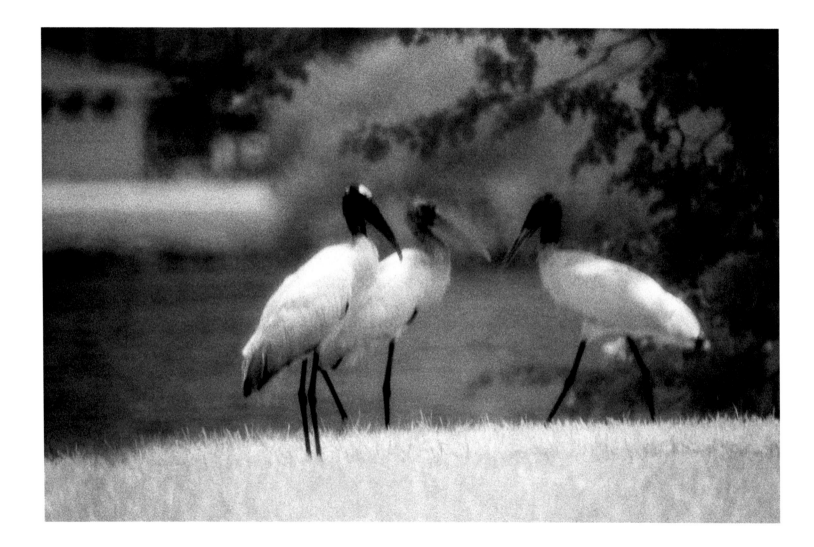

ABOVE: Wood Storks, Anna Maria Island, Florida, 1999 OPPOSITE: Wood Storks, Myakka River Valley, Sarasota County, Florida, 2006
GATEFOLD: Wood Stork landing, Myakka River Valley, Sarasota County, Florida, 2005

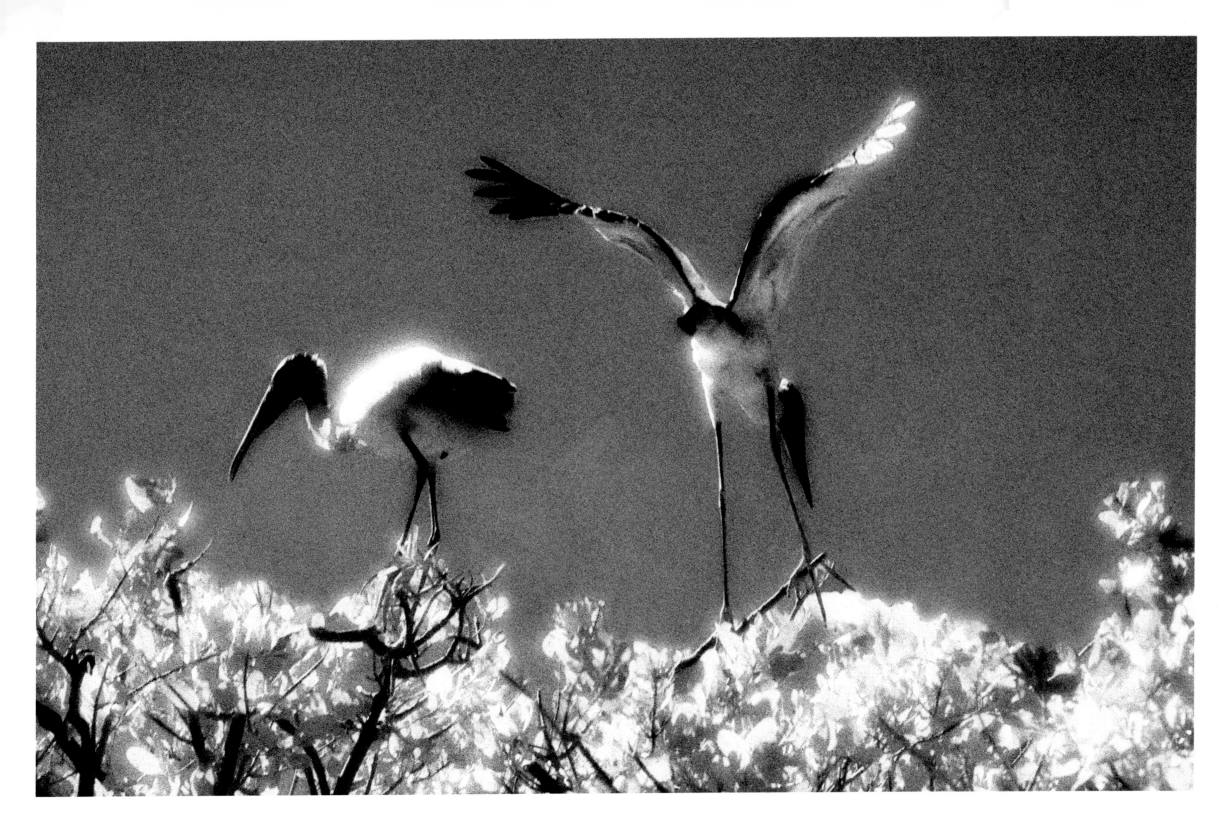

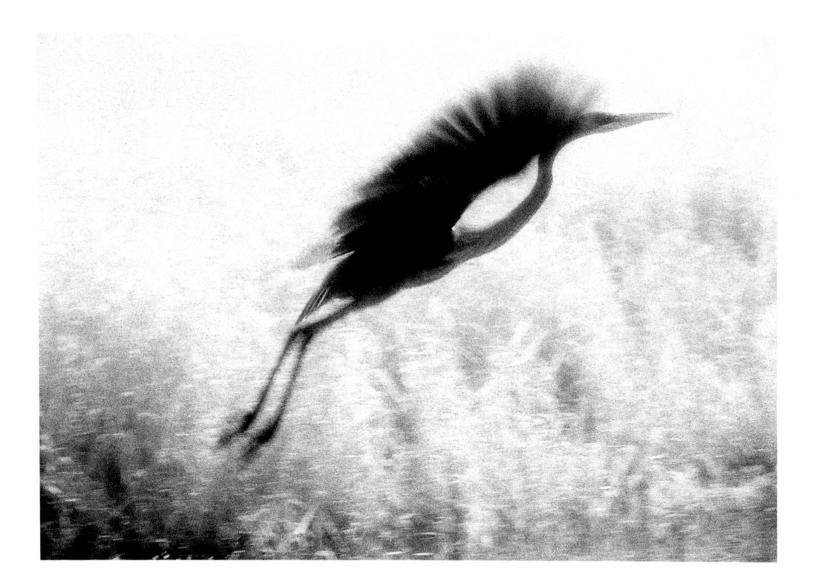

Great Blue Heron, Farmington, Davis County, Utah, 2007 OPPOSITE: White-faced Ibises, Farmington Bay, Great Salt Lake, Farmington, Utah, 2005

FOLLOWING PAGES: Wilson's Phalaropes, Antelope Island causeway, Great Salt Lake, Utah, 2002

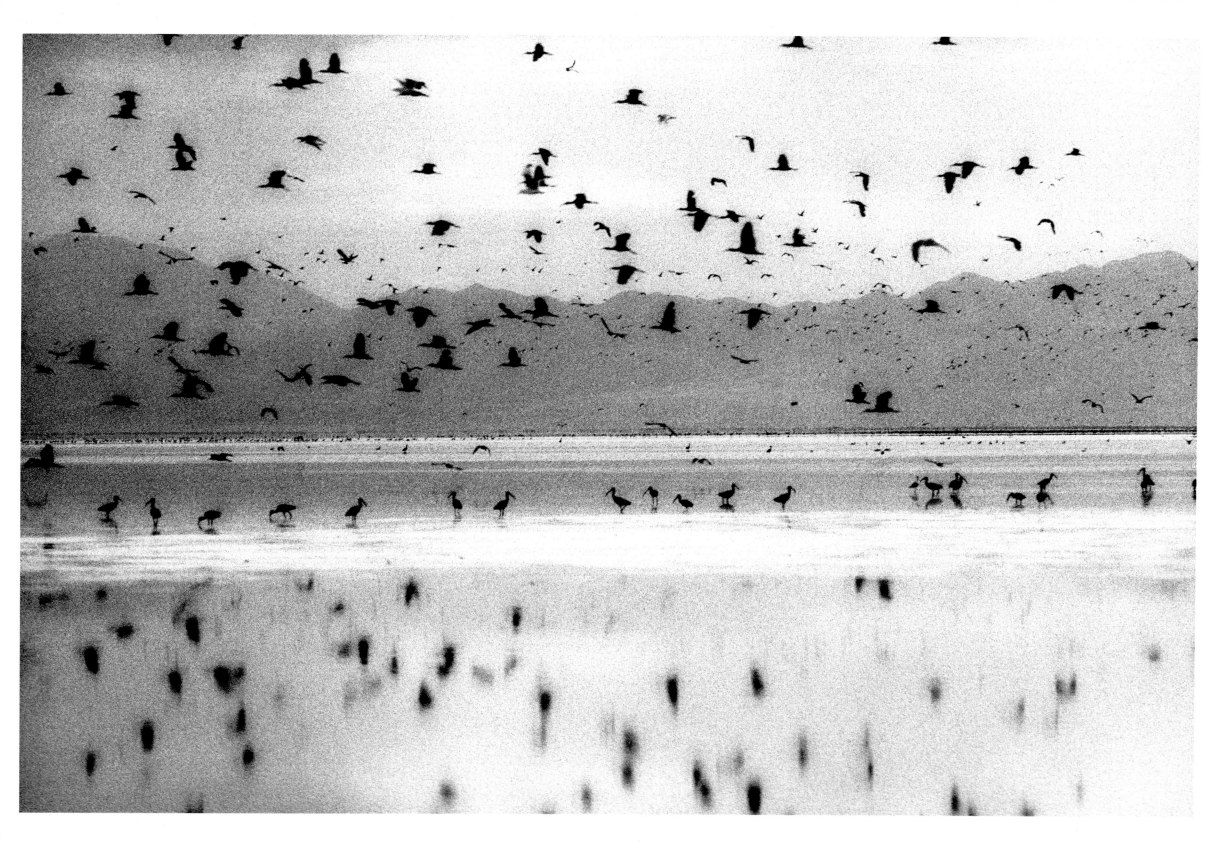

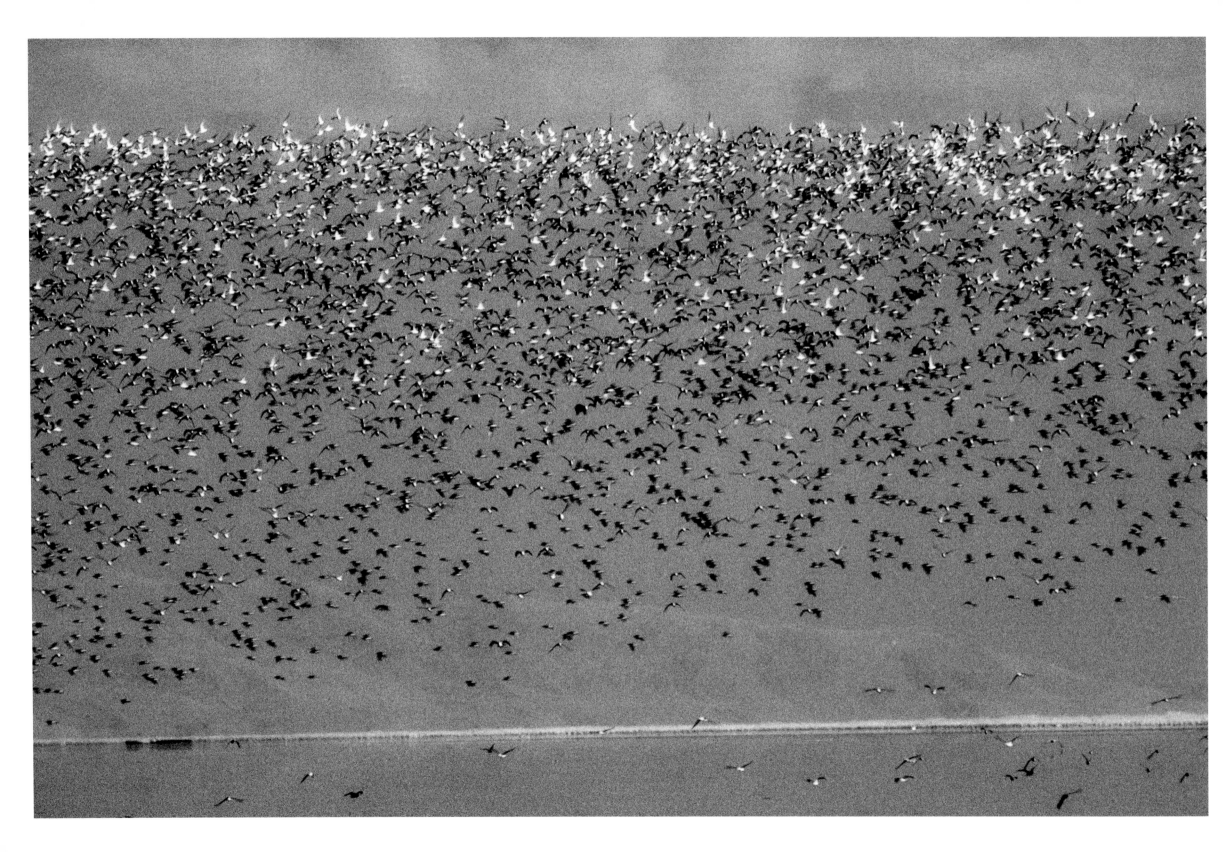

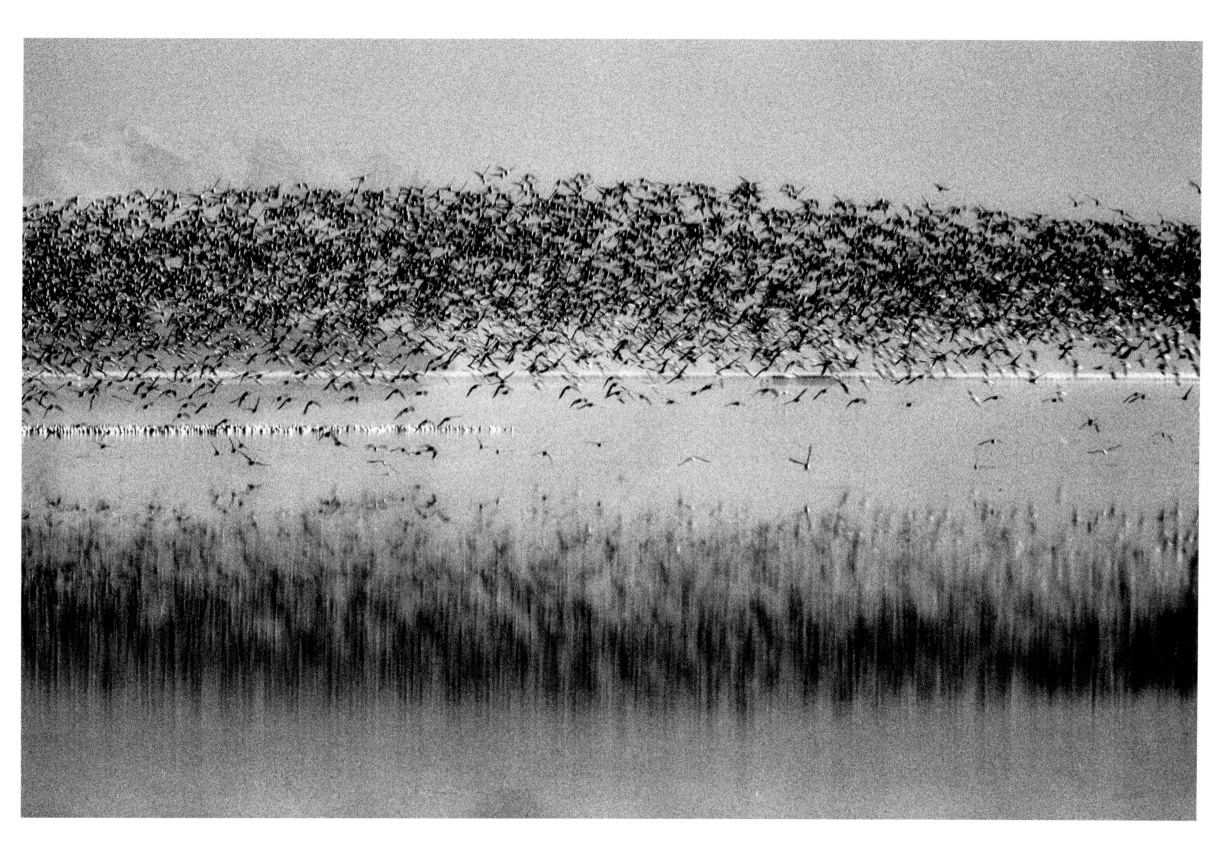

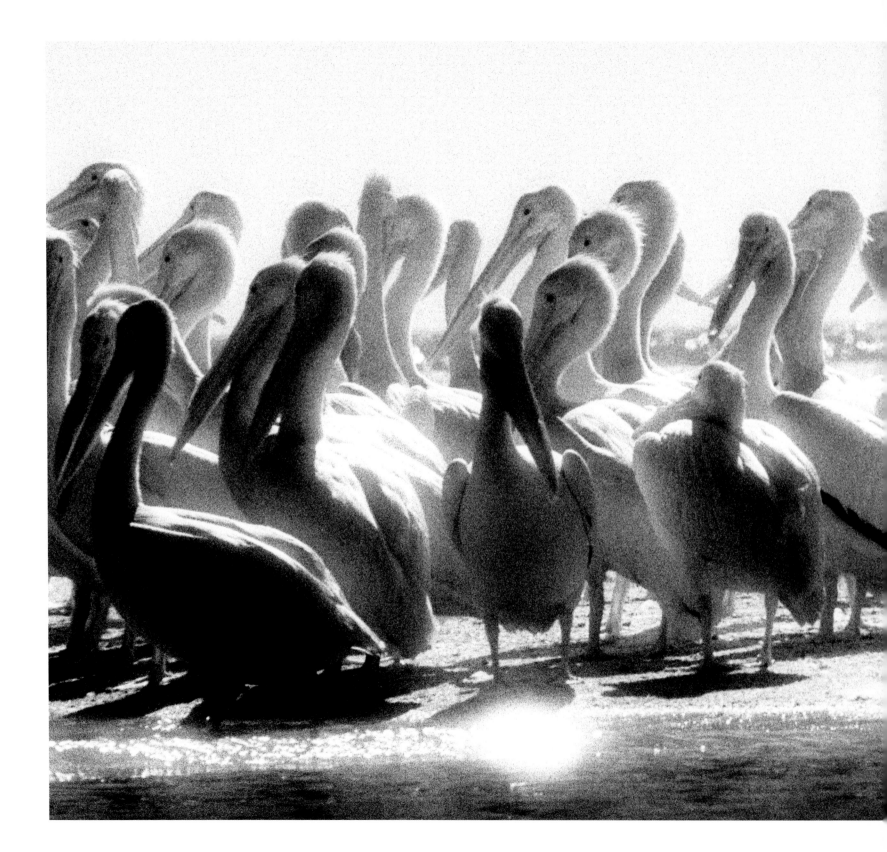

White Pelicans, Gulf of Mexico near
Captiva Island, Florida, 2004

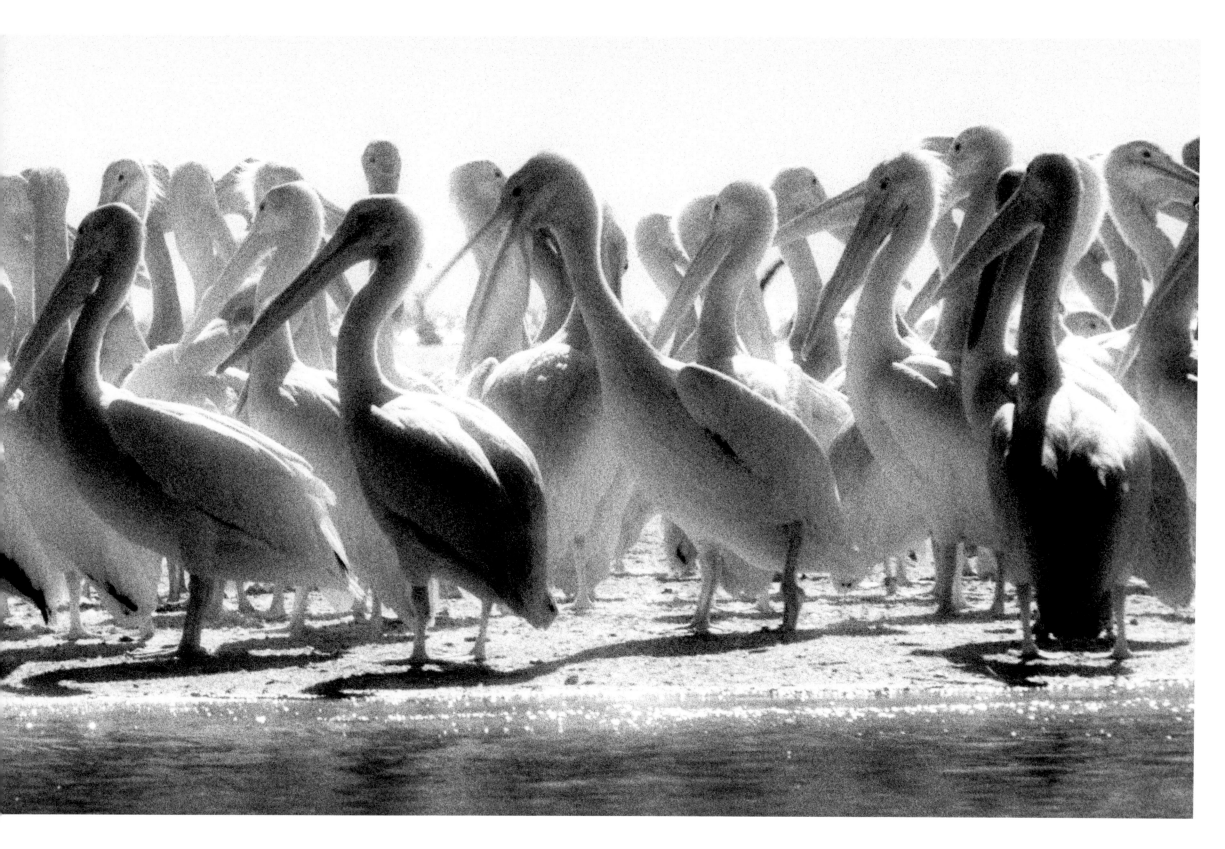

It is not only fine feathers that make fine birds.

— aesop

Sandhill Crane, Nokomis, Florida, 2006

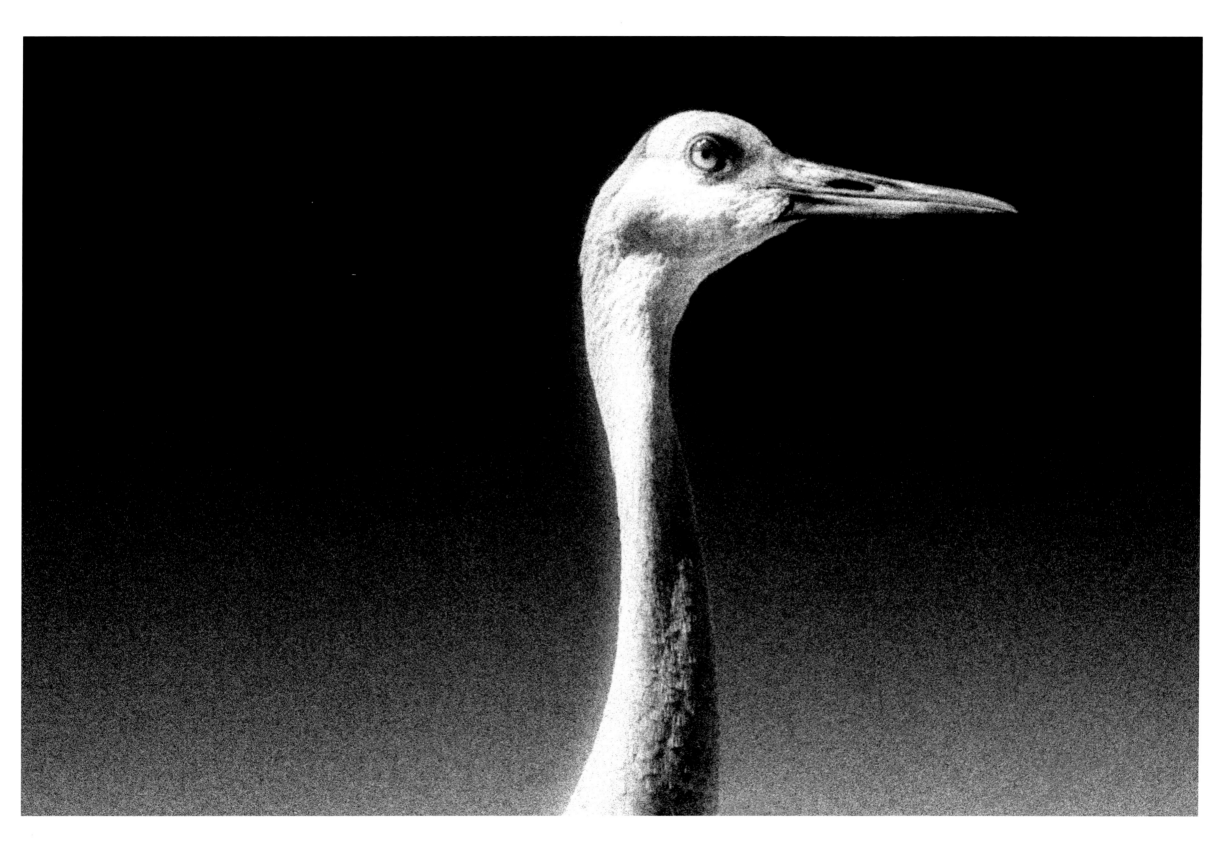

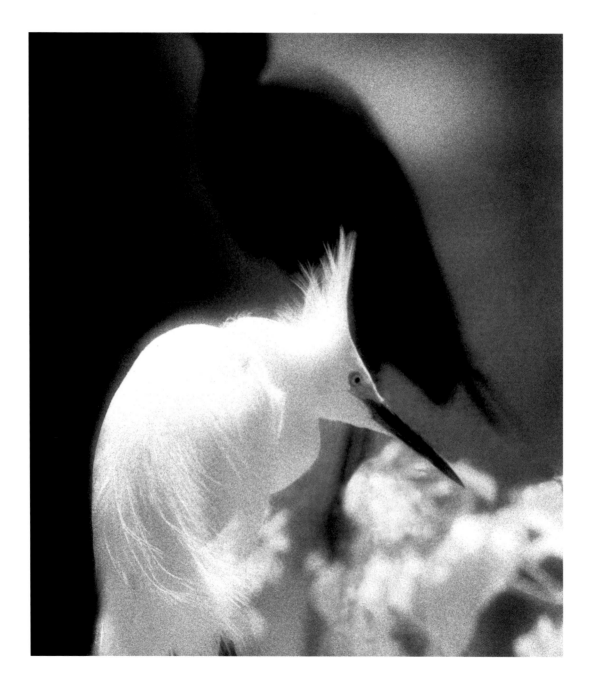

Snowy Egret, Lake Martin, Breaux Bridge, Louisiana, 2004

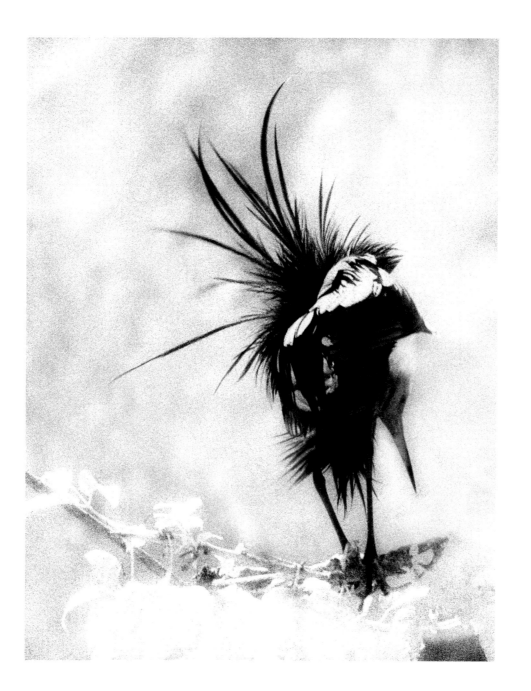

Little Blue Heron, Lake Martin, Breaux Bridge, Louisiana, 2004

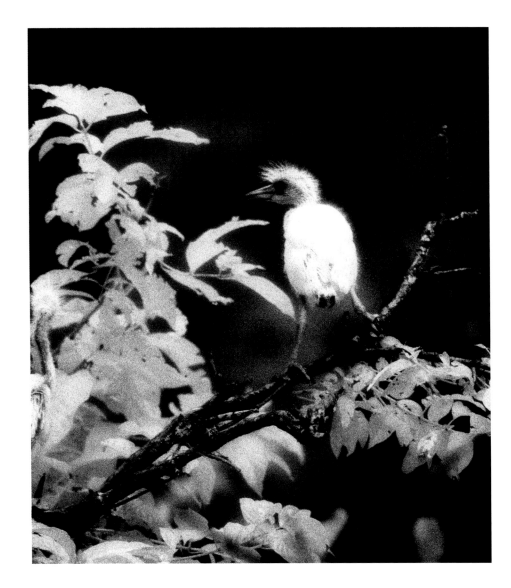

Great Egret chick, Lake Martin, Breaux Bridge, Louisiana, 2004 OPPOSITE: Great Egret on Moonvine-cloaked Mangroves, Lido Key, Sarasota, 1997

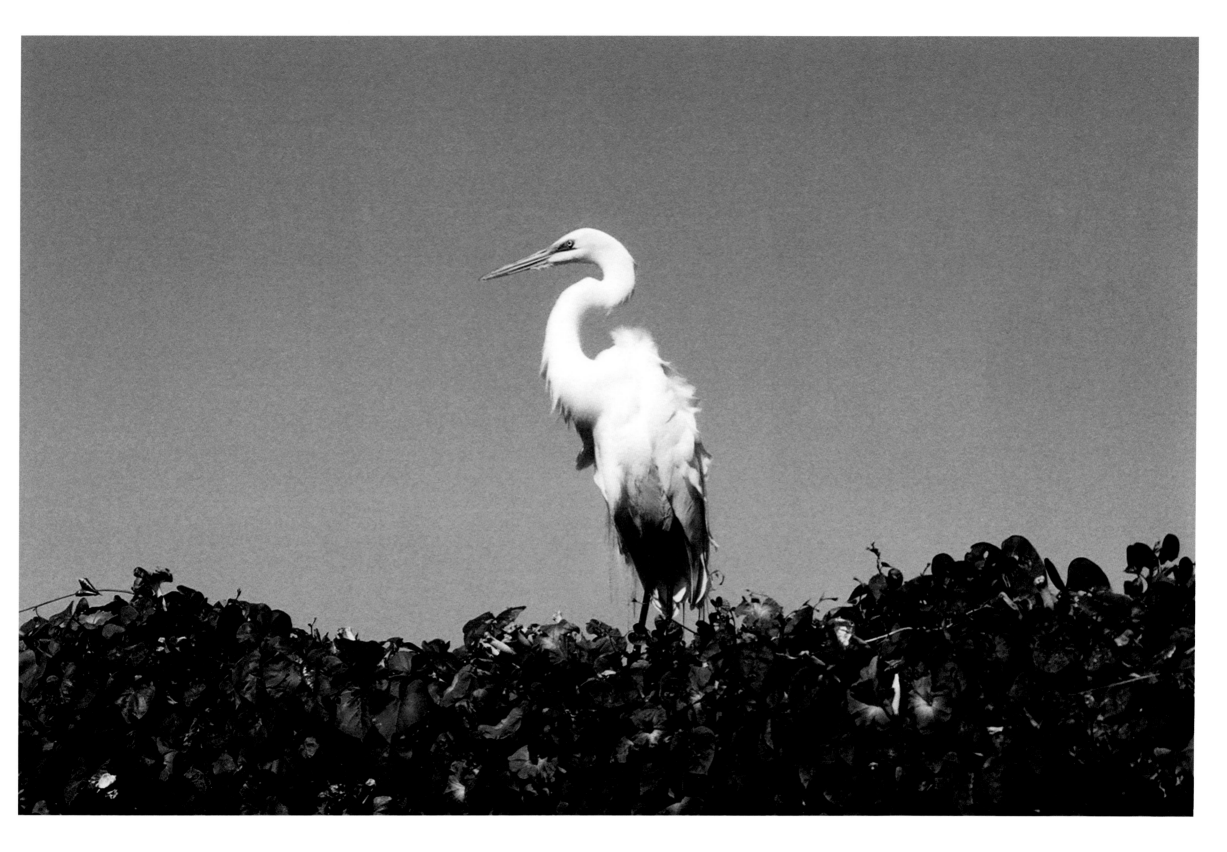

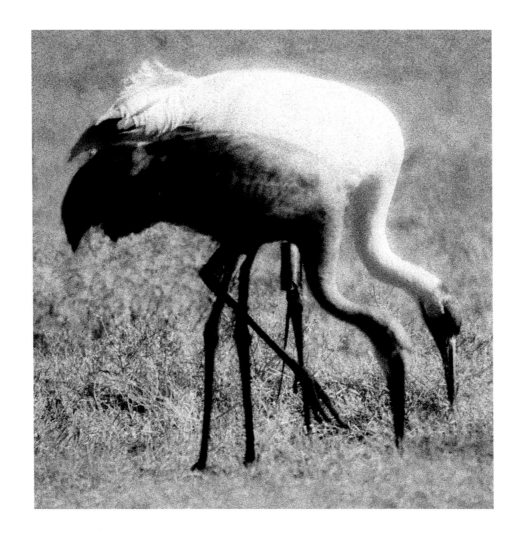

ABOVE: Sandhill Crane & Whooping Crane, Kenansville, Florida, 2004 OPPOSITE: Brahman Bull & Sandhill Crane, Kenansville, Florida, 2004

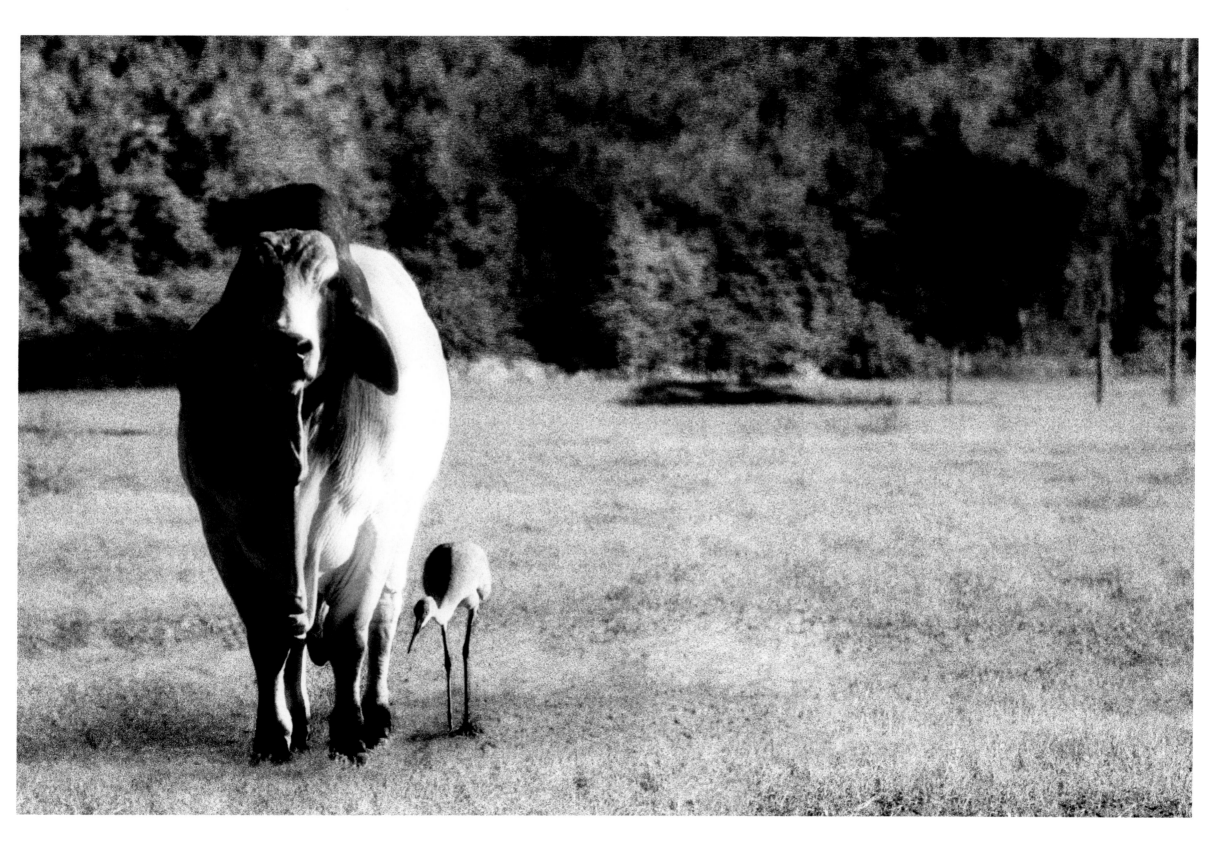

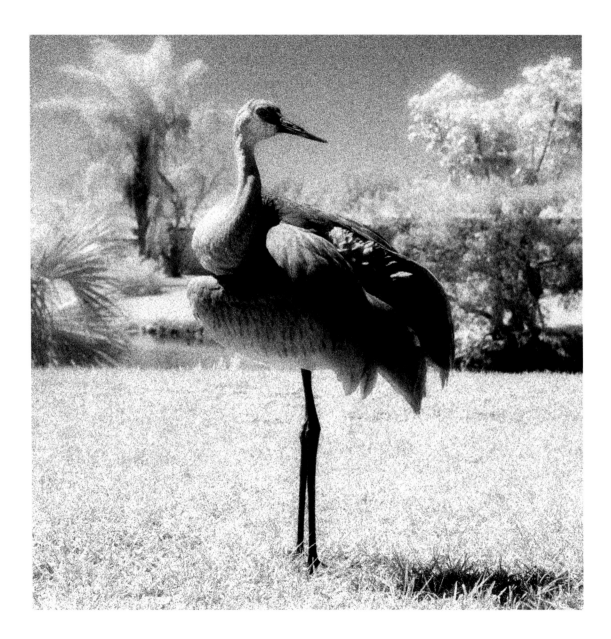

ABOVE: Sandhill Crane, Nokomis, Florida, 2006 OPPOSITE: Sandhill Cranes, Platte River Valley near Grand Island, Nebraska, 2004

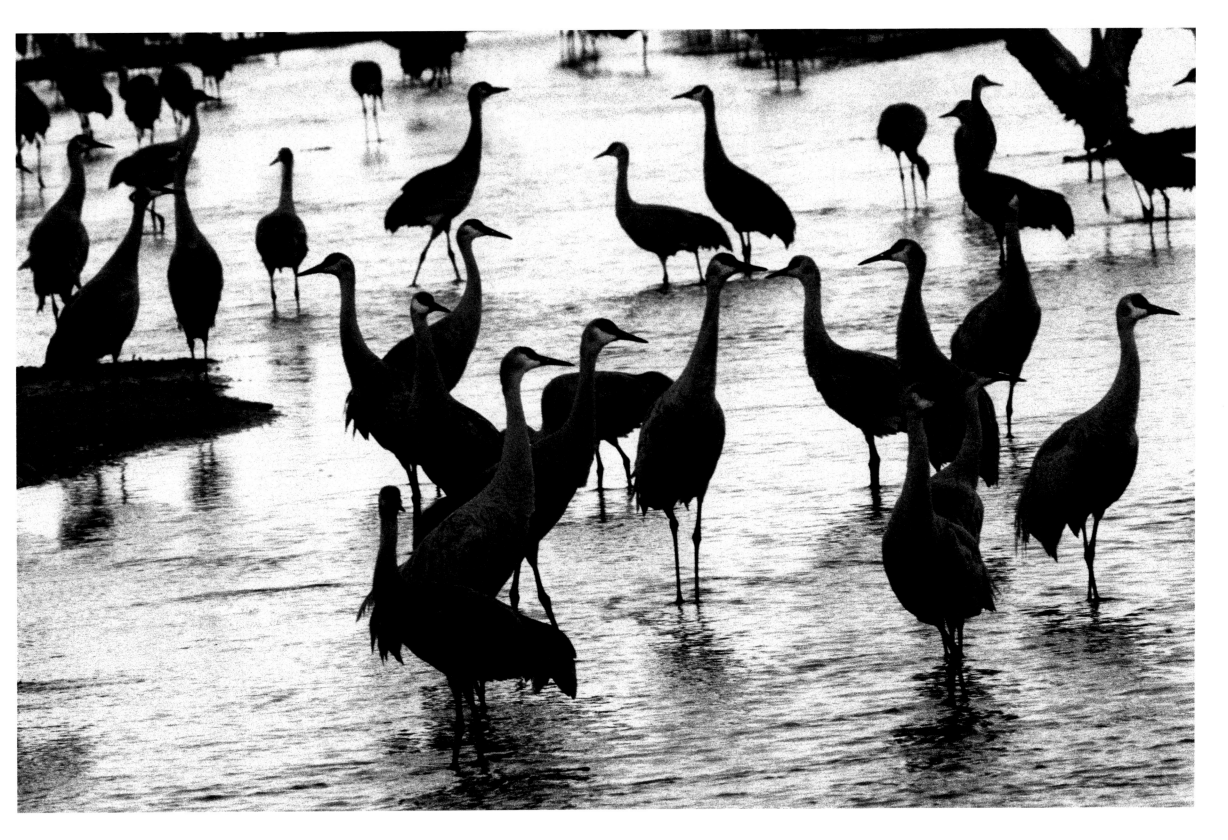

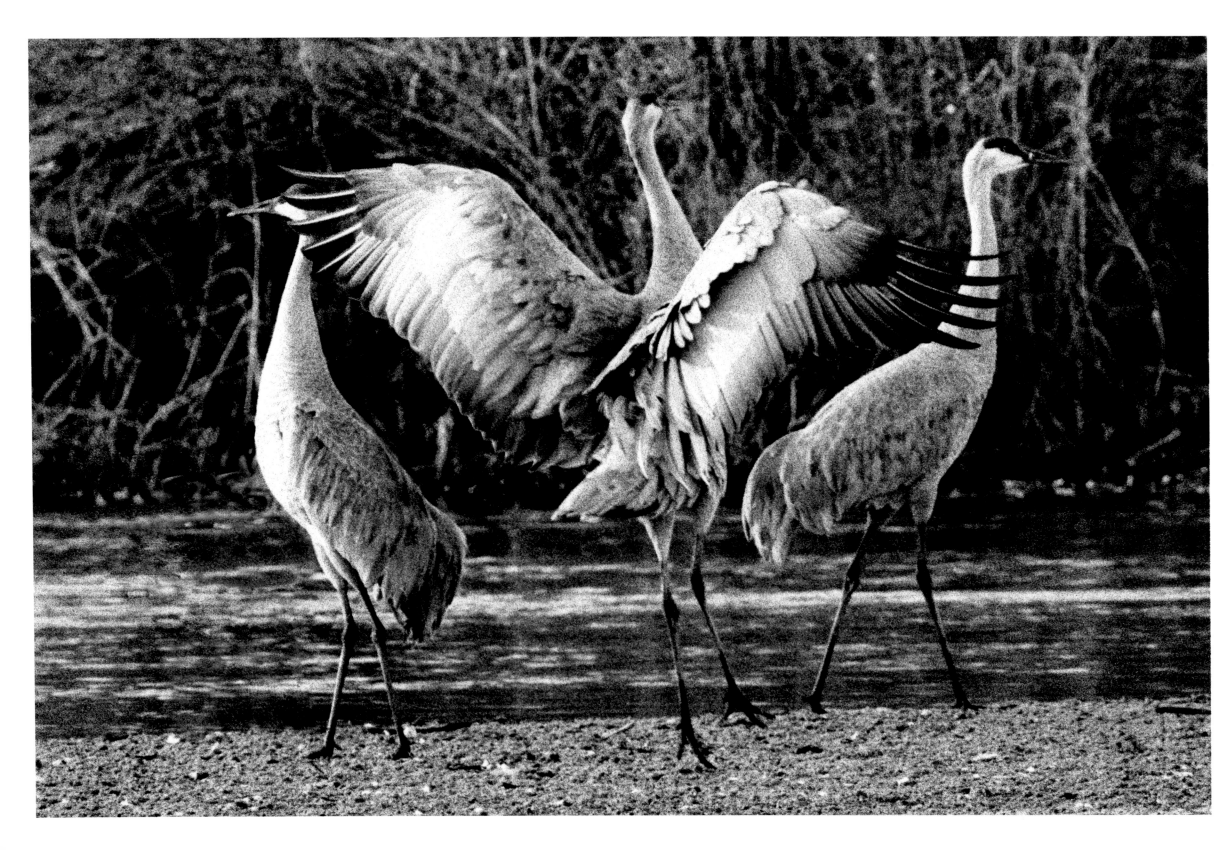

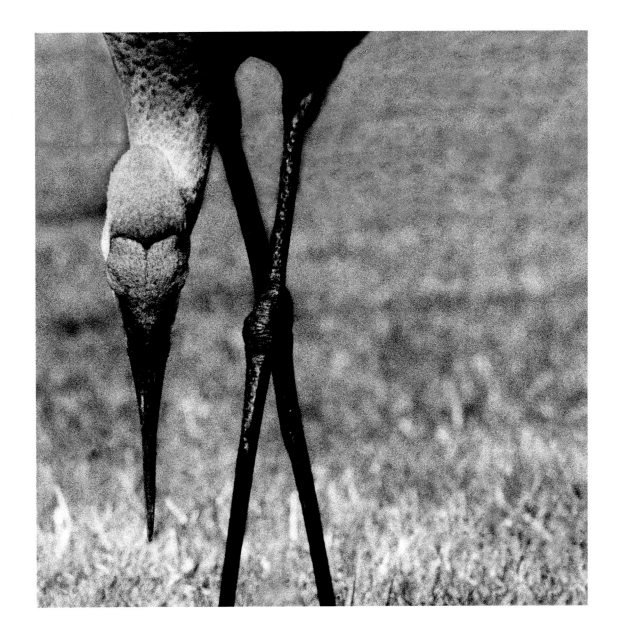

OPPOSITE: Sandhill Cranes, Platte River Valley near Grand Island, Nebraska, 2004 ABOVE: Sandhill Crane, Nokomis, Florida, 2006

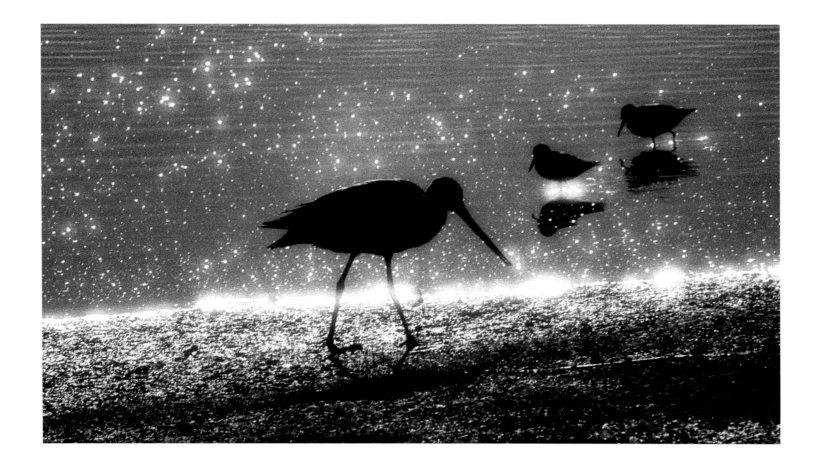

ABOVE: Marbled Godwit and Dunlins, Heart's Desire Beach, Point Reyes Peninsula, California, 2004 OPPOSITE: Wood Stork, Anna Maria Island, Florida, 1999

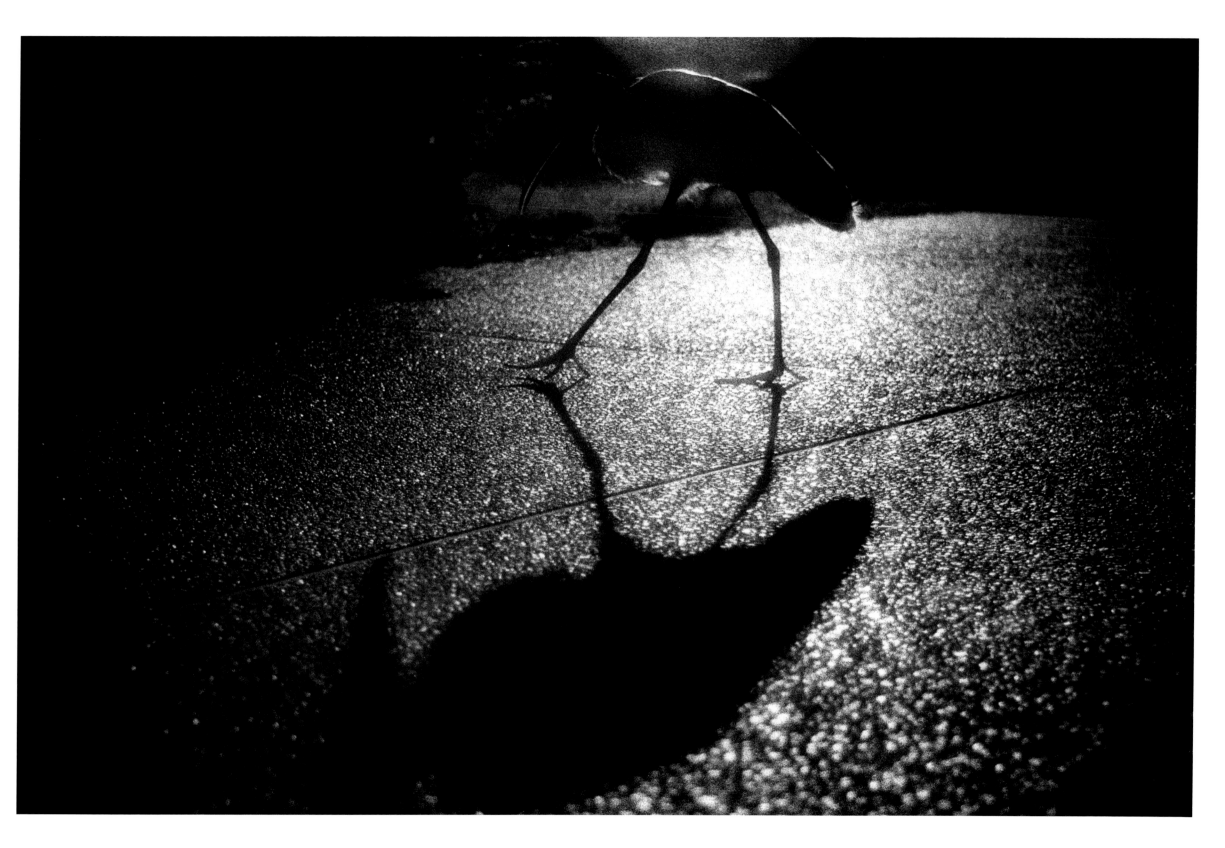

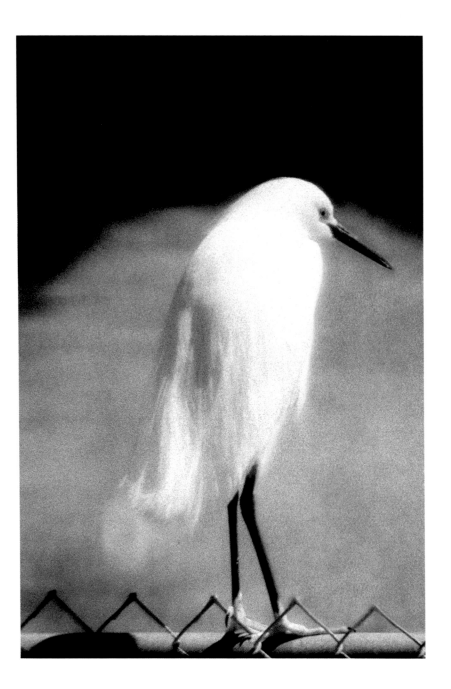

ABOVE: Snowy Egret, Ballona Wetlands, Los Angeles, California, 2000 OPPOSITE: Great Egret, Venice, Florida, 2005

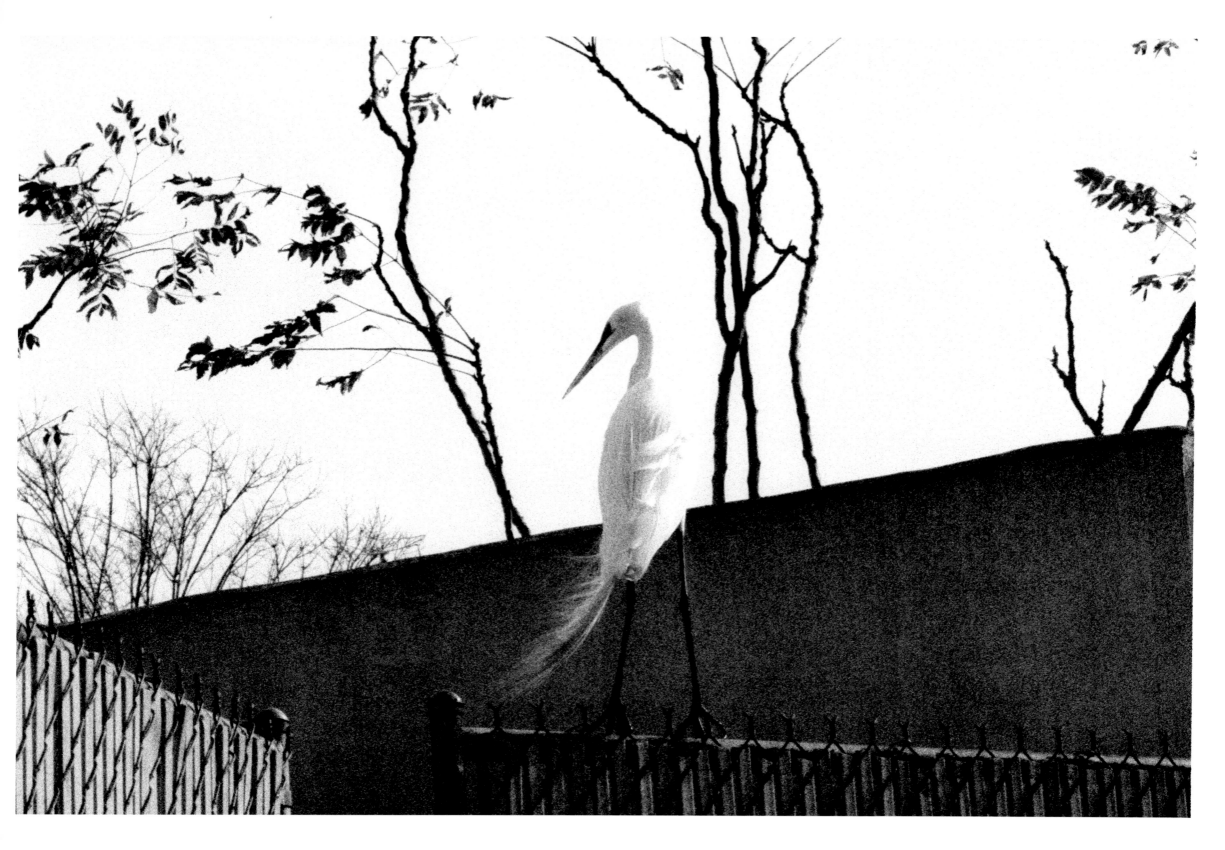

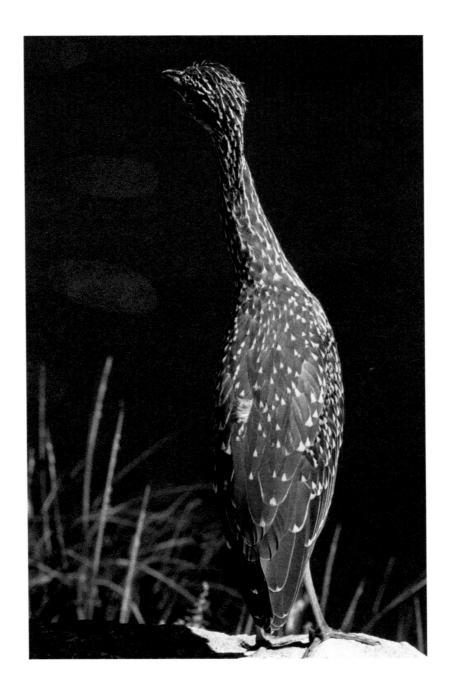

ABOVE: Immature Yellow-crowned Night Heron, Long Island Sound, Mamaroneck, New York, 2007 OPPOSITE: Tri-colored Heron, J. N. "Ding" Darling National Wildlife Refuge, Sanibel Island, Florida, 2004

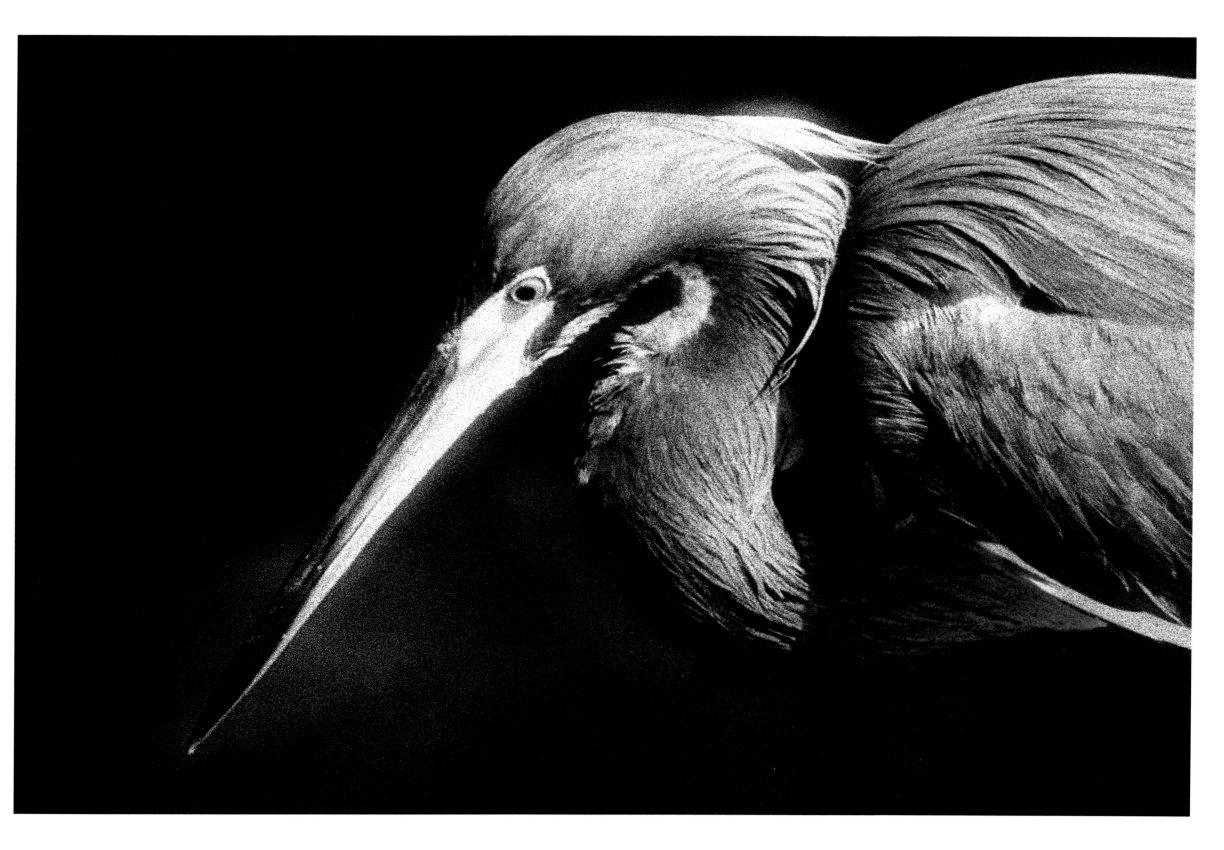

Oh, the flight from the mirroring water,
a thousand bodies aimed at a beautiful stillness
like the transparent permanence of the lake.

— pablo neruda

American Avocet, Farmington Bay, Great Salt Lake, Farmington, Utah, 2005

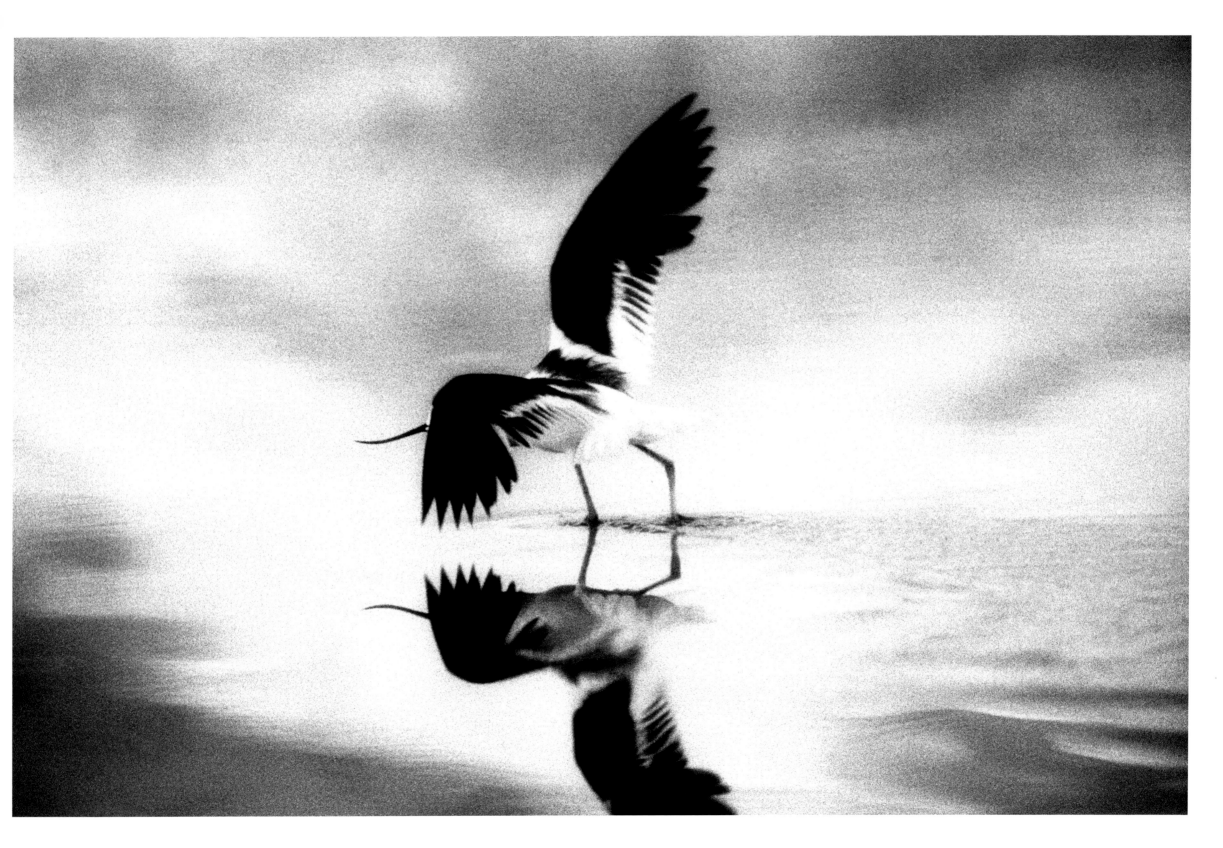

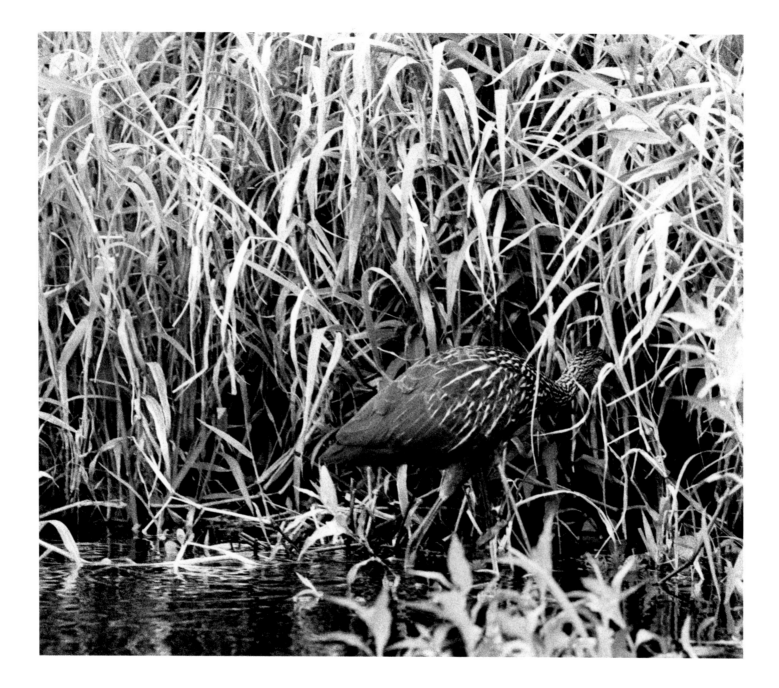

ABOVE: Limpkin, Myakka River Valley, Sarasota County, Florida, 2004 OPPOSITE: Long-billed Curlew, Heart's Desire Beach, Point Reyes Peninsula, California, 2005

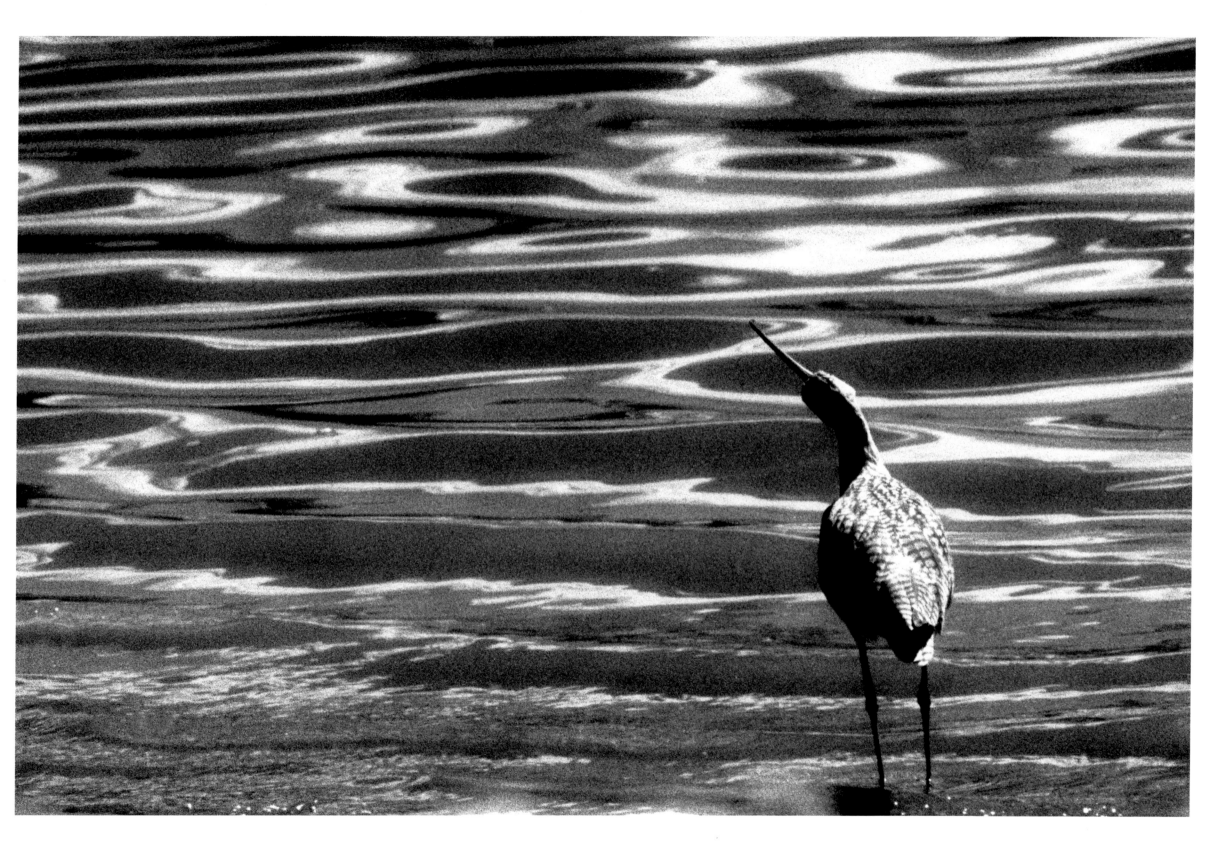

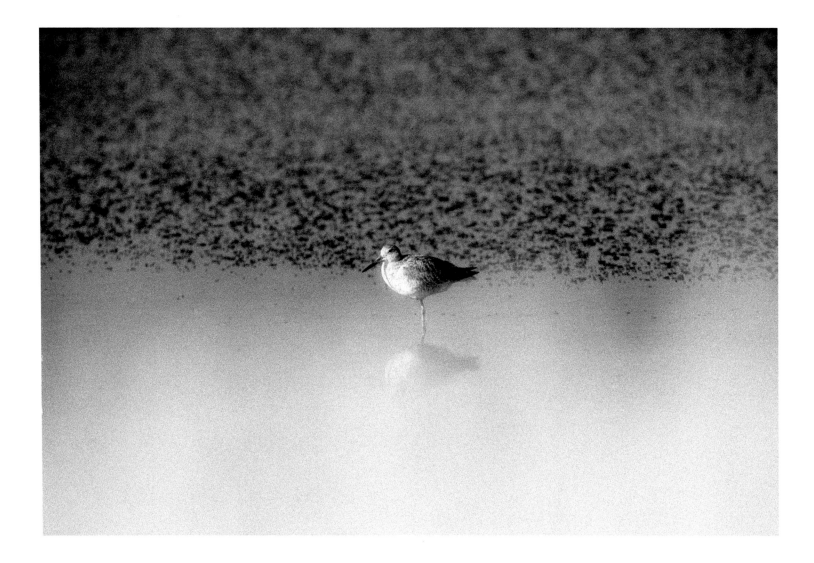

ABOVE: Willet, Antelope Island causeway, Great Salt Lake, Utah, 2003 OPPOSITE: American Avocets, Bear River Migratory Bird Refuge, Box Elder County, Utah, 2003

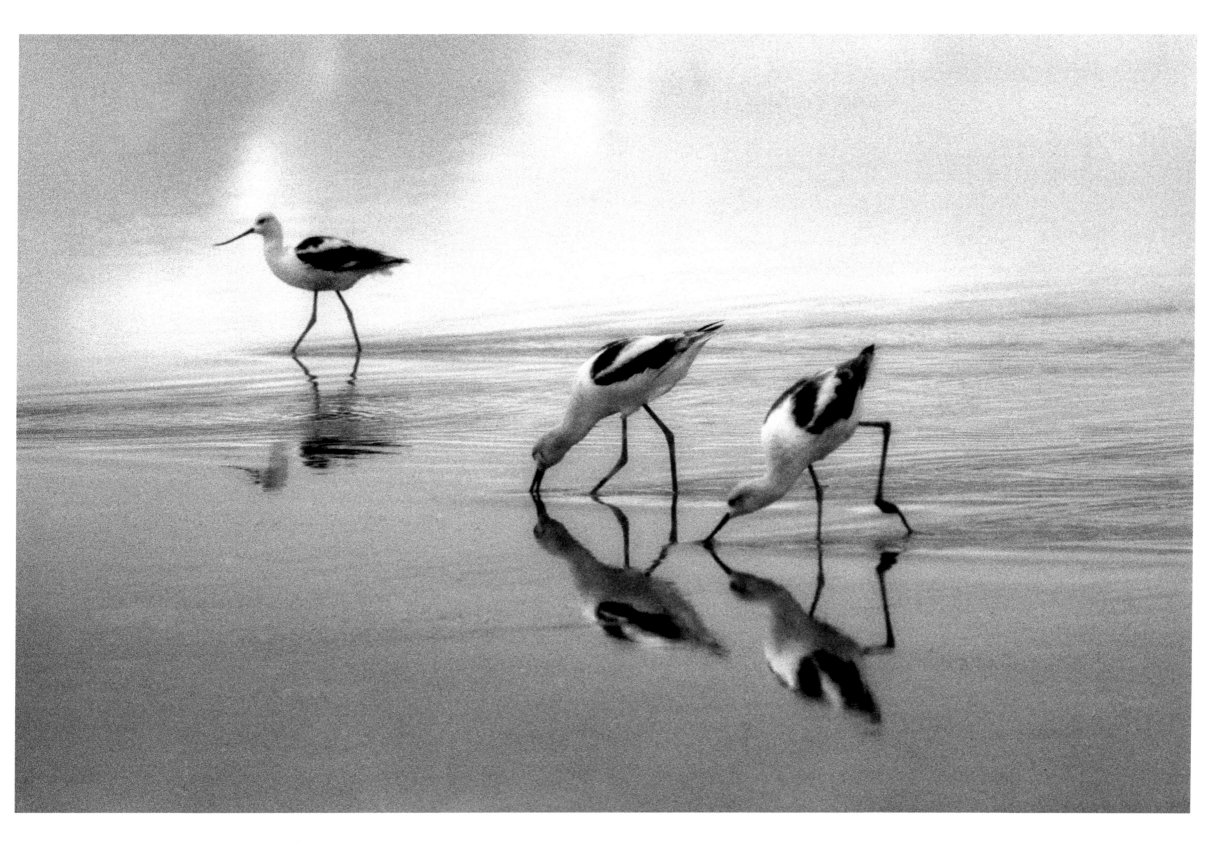

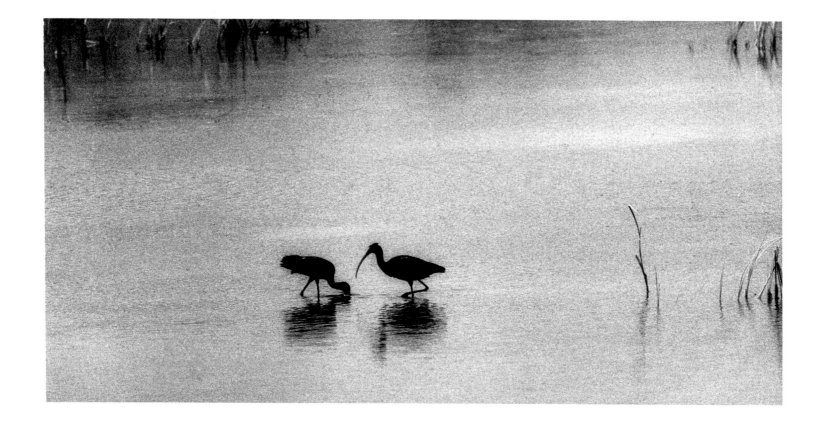

ABOVE: White-faced Ibises, Bear River Migratory Bird Refuge, Box Elder County, Utah, 2002 OPPOSITE: Sandhill Cranes, Platte River Valley near Grand Island, Nebraska, 2004

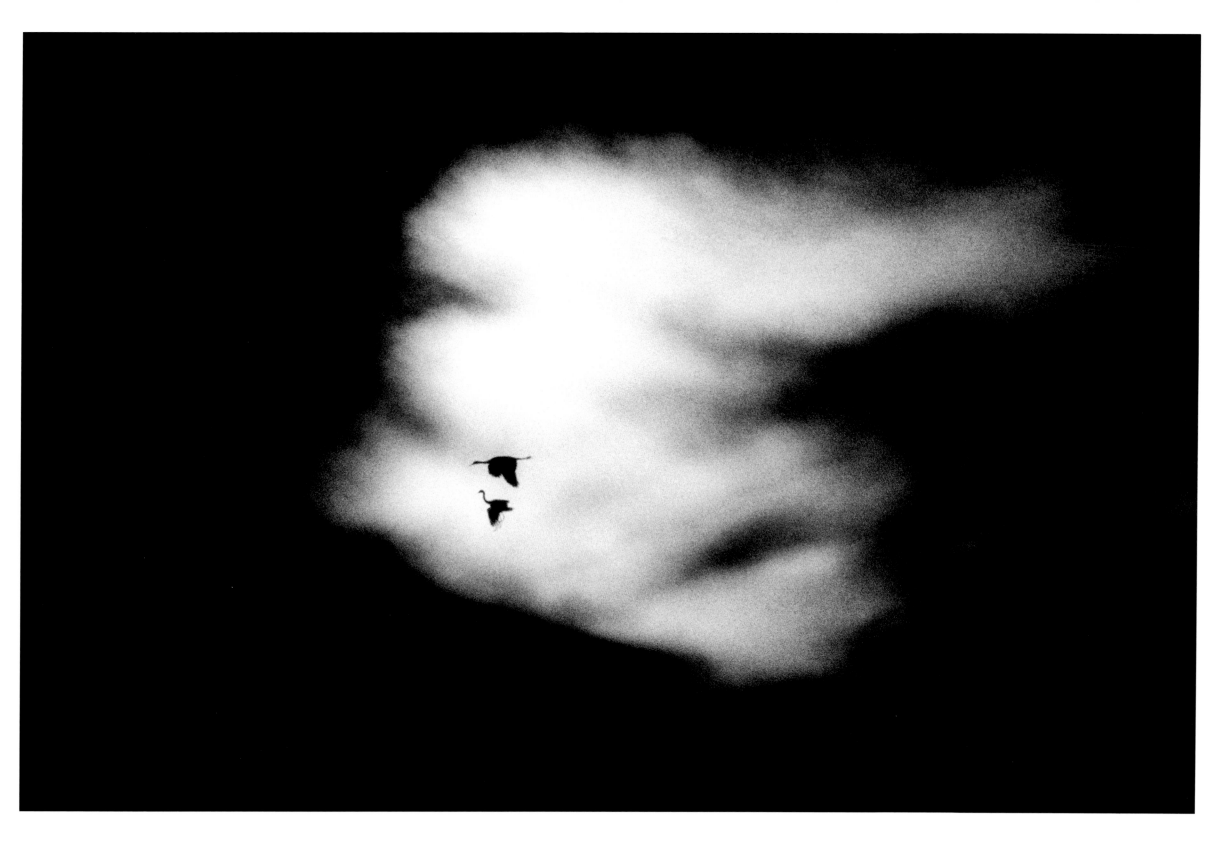

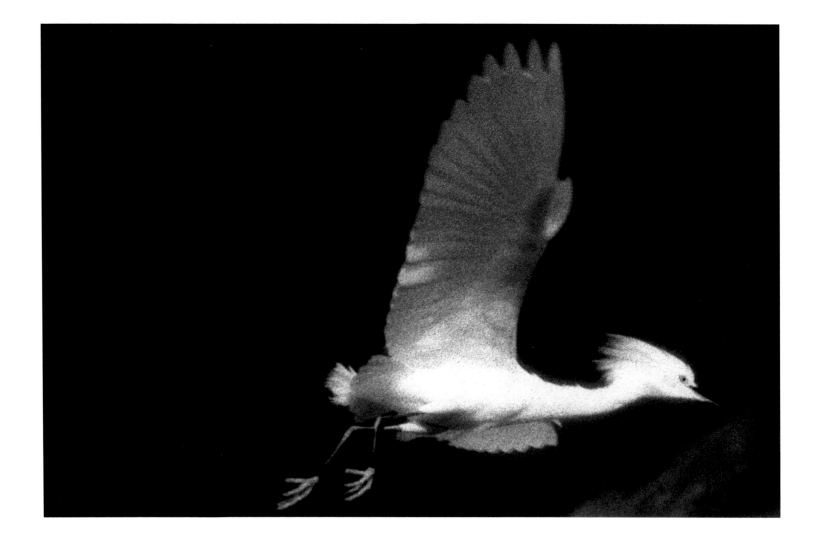

ABOVE: Snowy Egret, Anna Maria Island, Florida, 1998 OPPOSITE: Great Egret and Laughing Gull, New Pass, Sarasota, Florida, 1997
GATEFOLD: Great Egret and Brown Pelicans, New Pass, Sarasota, Florida, 1997

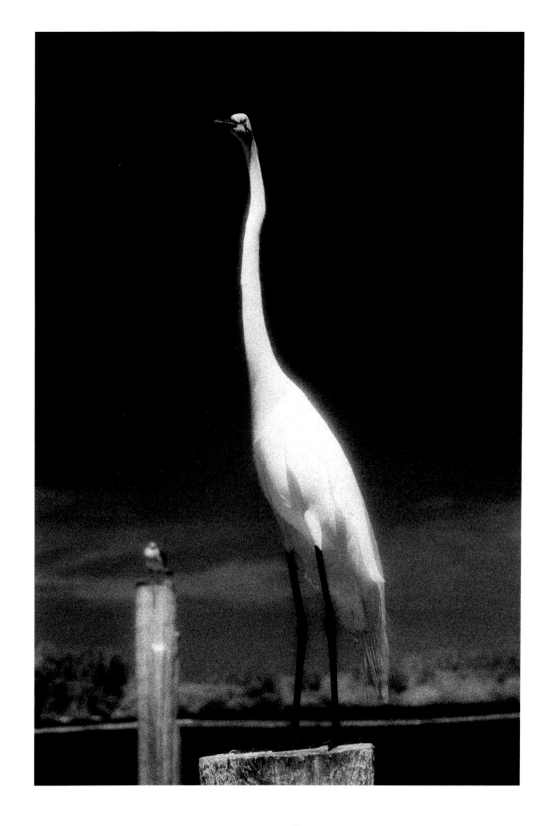

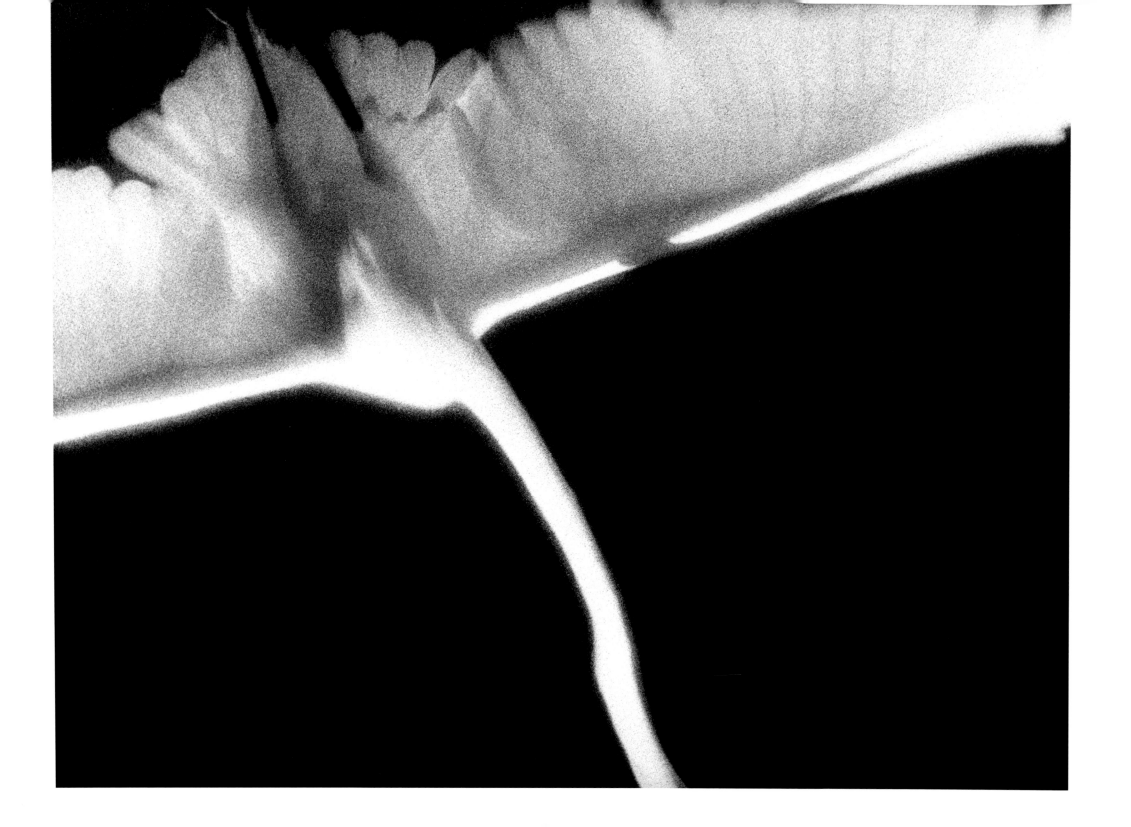

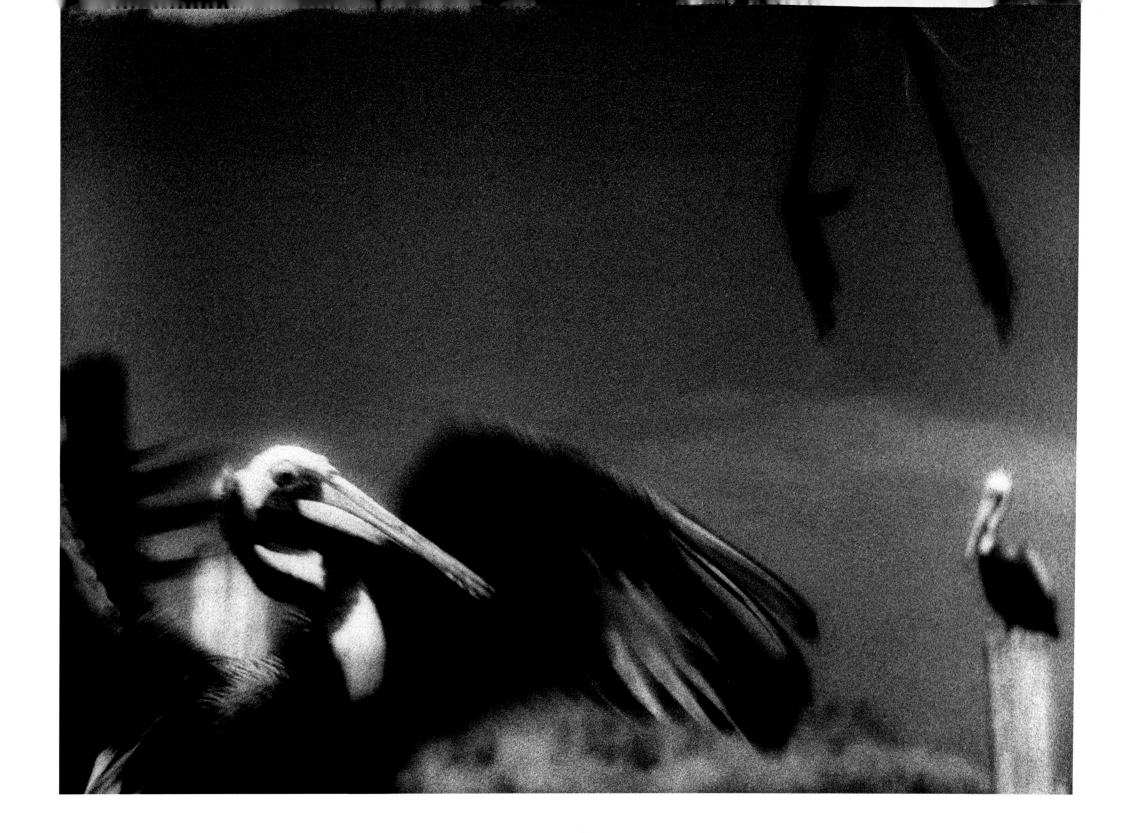

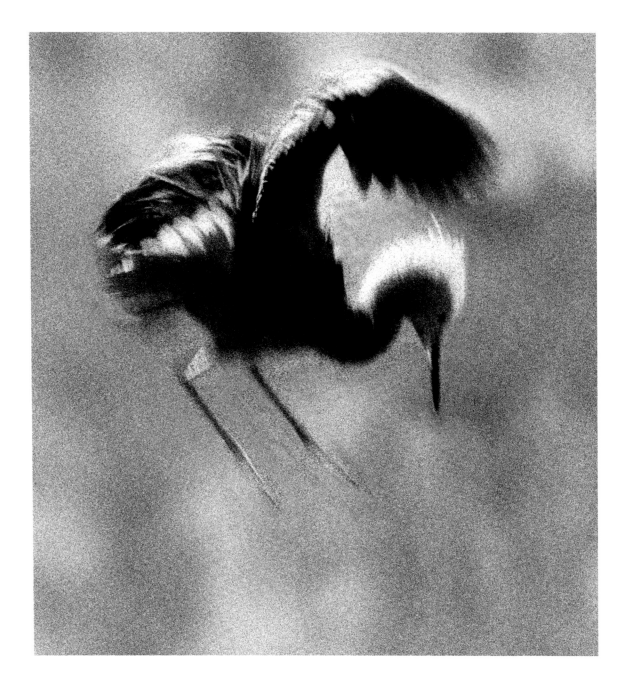

PRECEDING PAGES: White Ibises, J. N. "Ding" Darling National Wildlife Refuge, Sanibel Island, Florida, 2004 ABOVE: Little Blue Heron, Lake Martin, Breaux Bridge, Louisiana, 2004
OPPOSITE: Snowy Egrets, Great Egret, Laughing Gull, New Pass, Sarasota, Florida, 1998

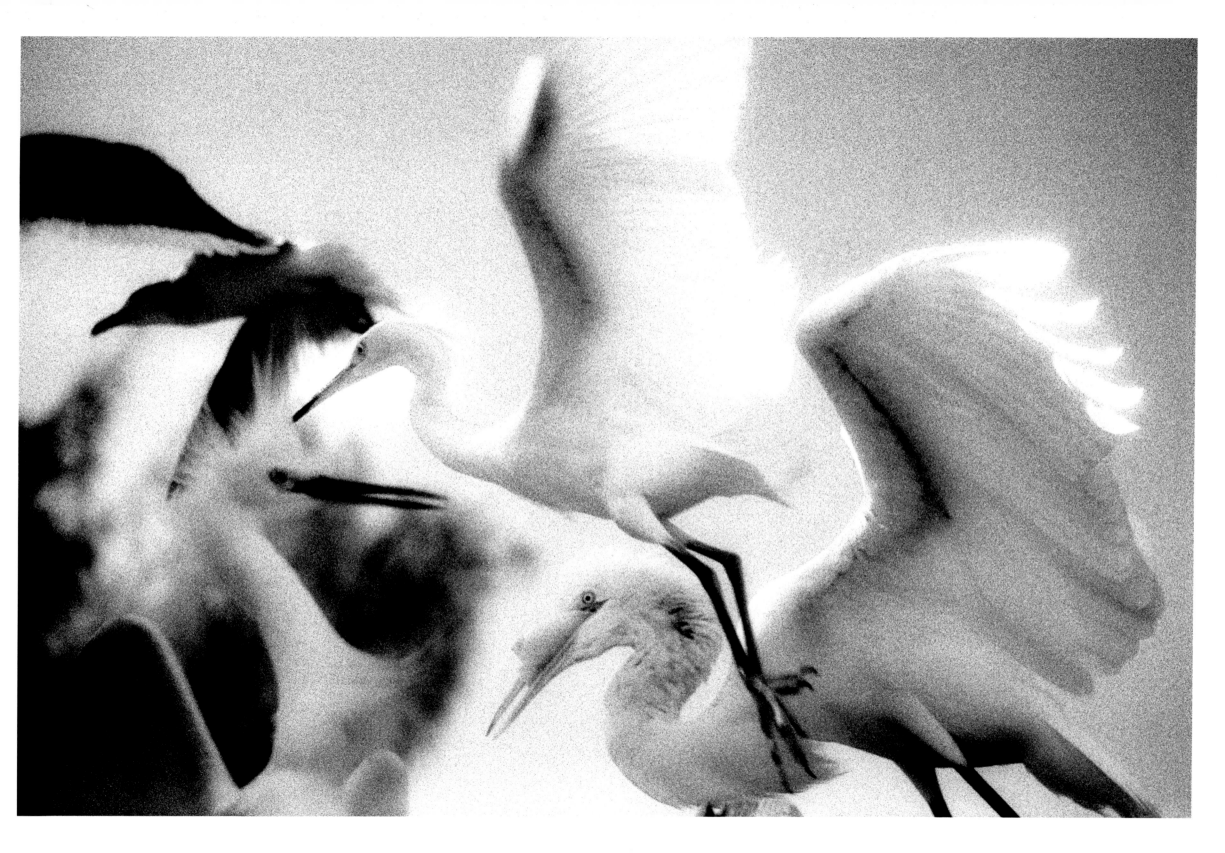

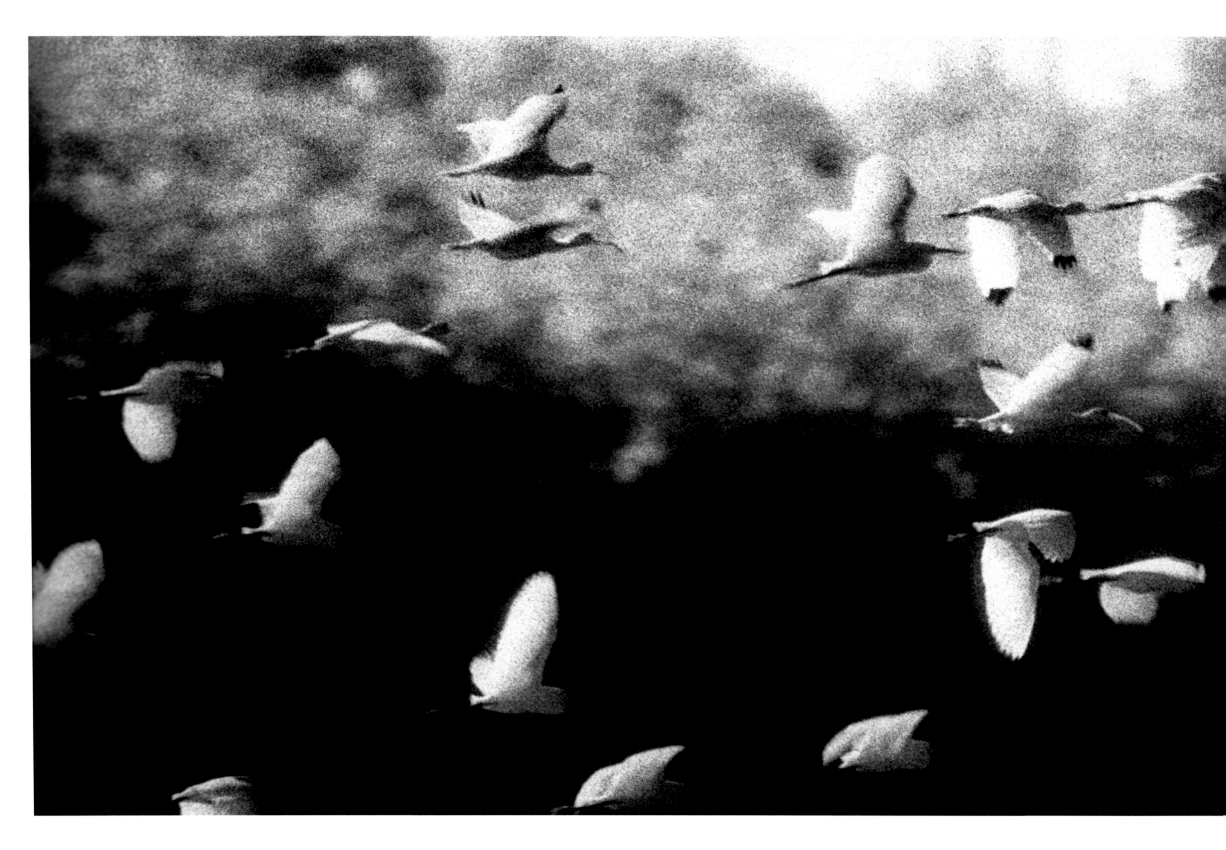

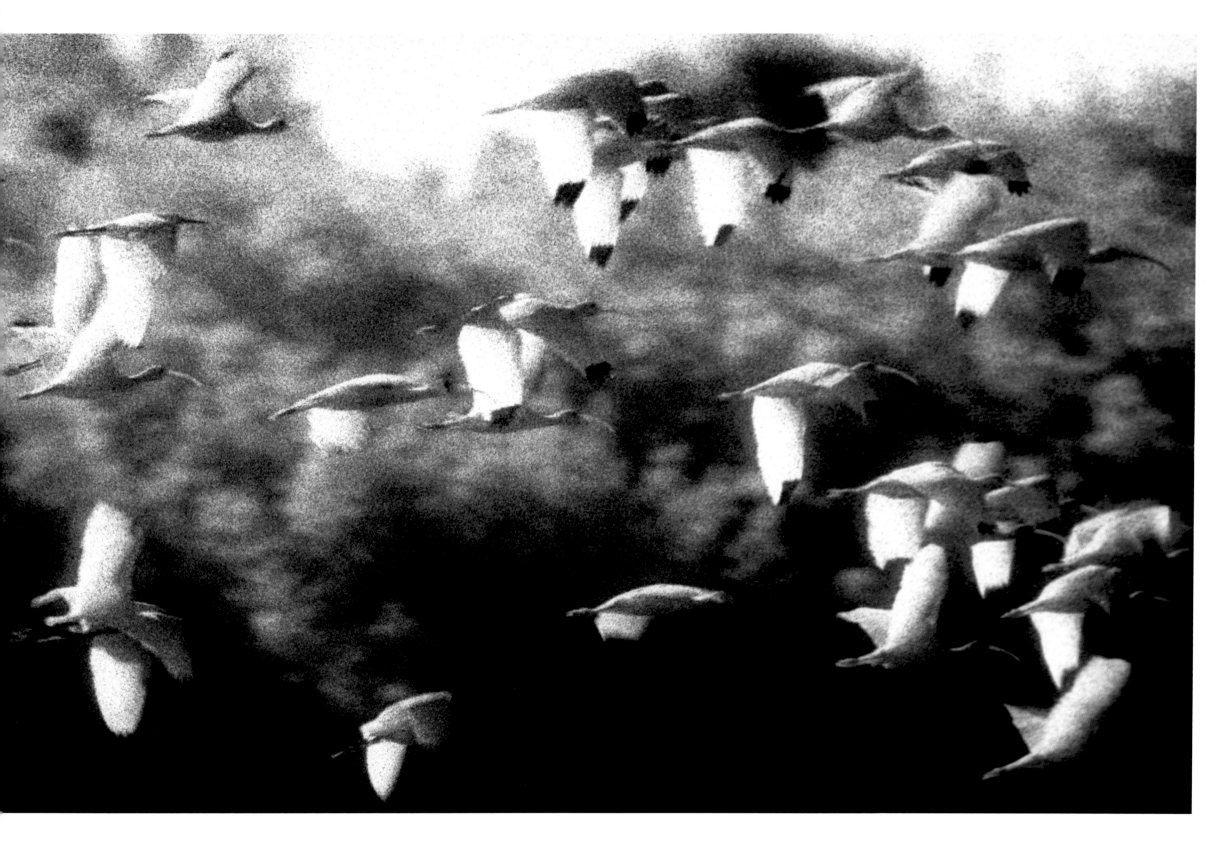

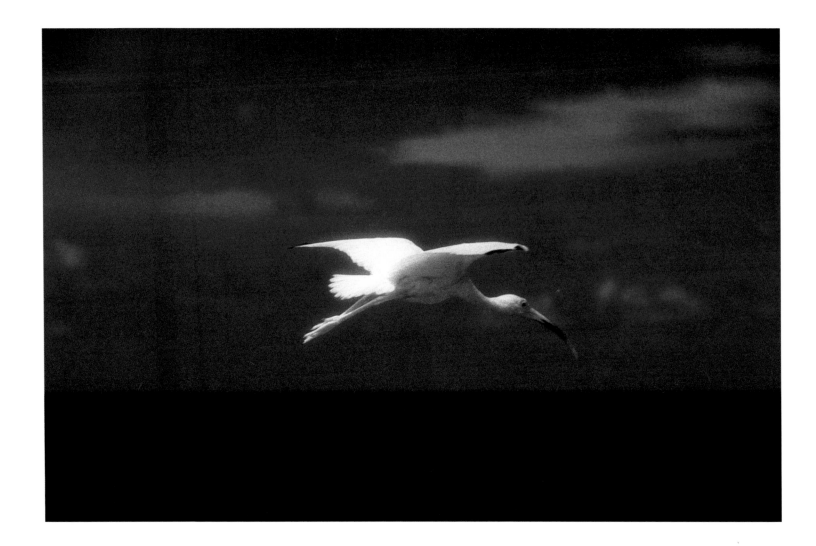

ABOVE: White Ibis, Lido Beach, Sarasota, Florida 2003 OPPOSITE: White Ibises, Matlacha, Florida, 2004

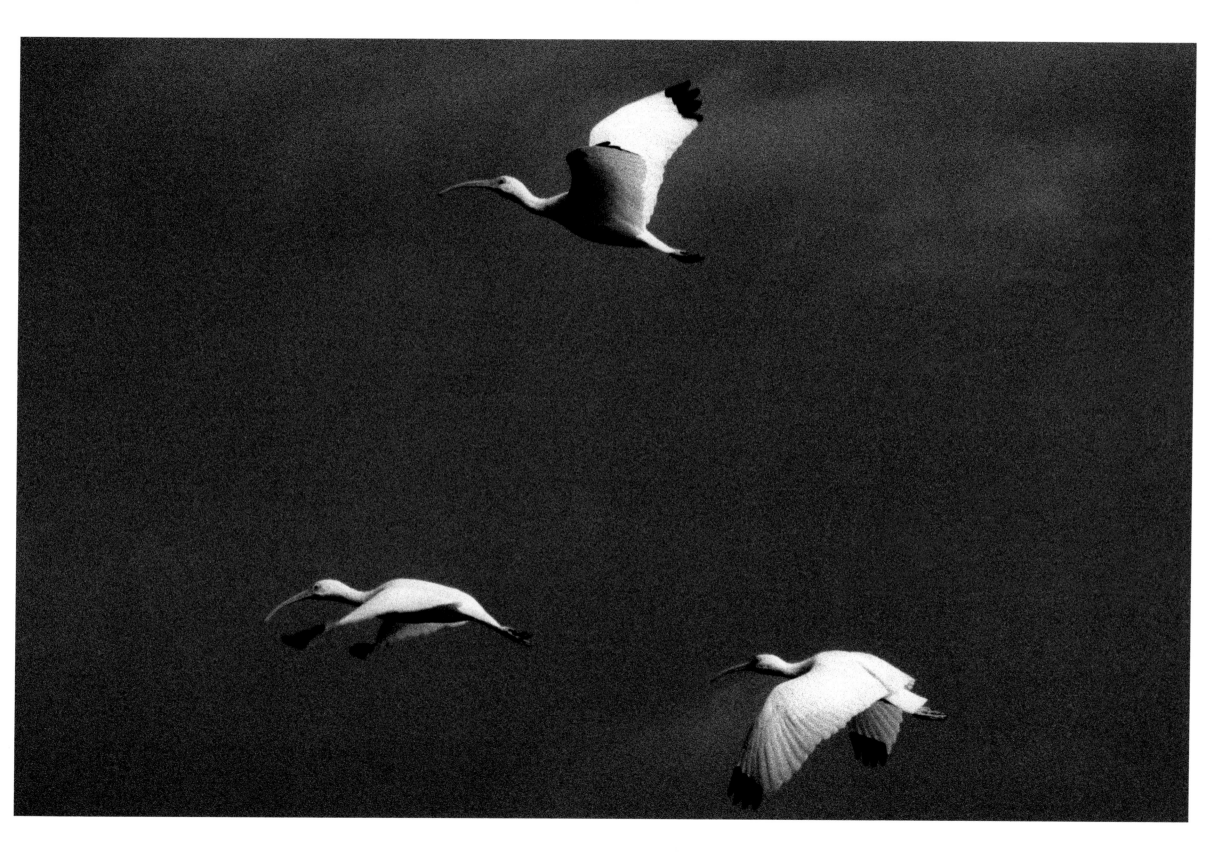

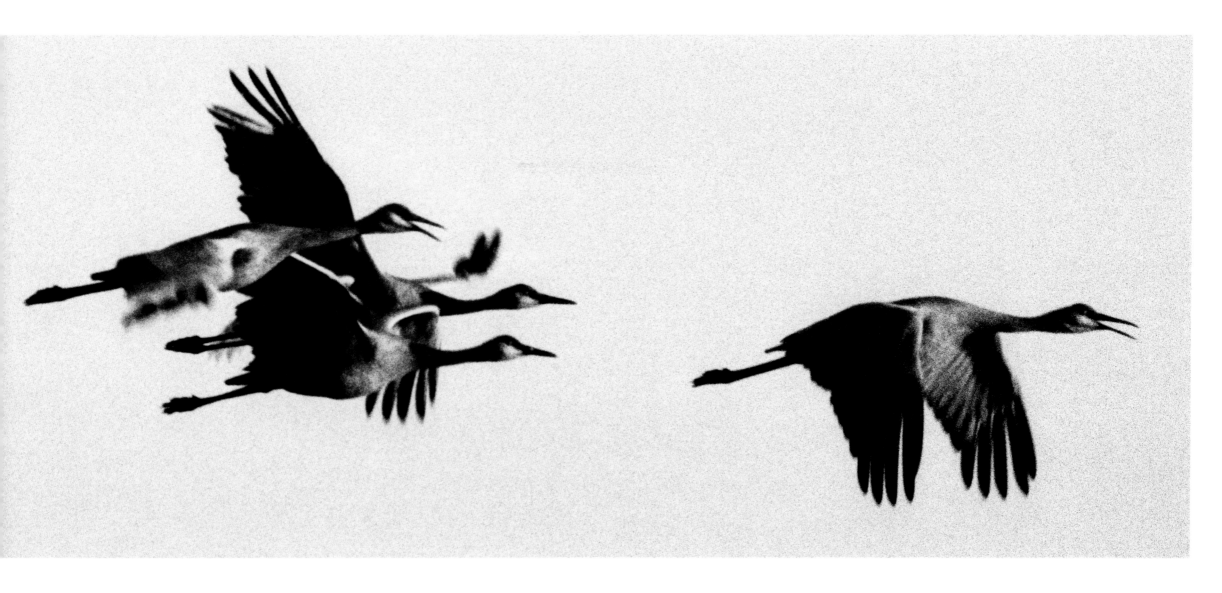

ABOVE: Sandhill Cranes, Platte River Valley near Grand Island, Nebraska, 2004 FOLLOWING PAGES: Sandhill Cranes, Platte River Valley near Grand Island, Nebraska, 2003

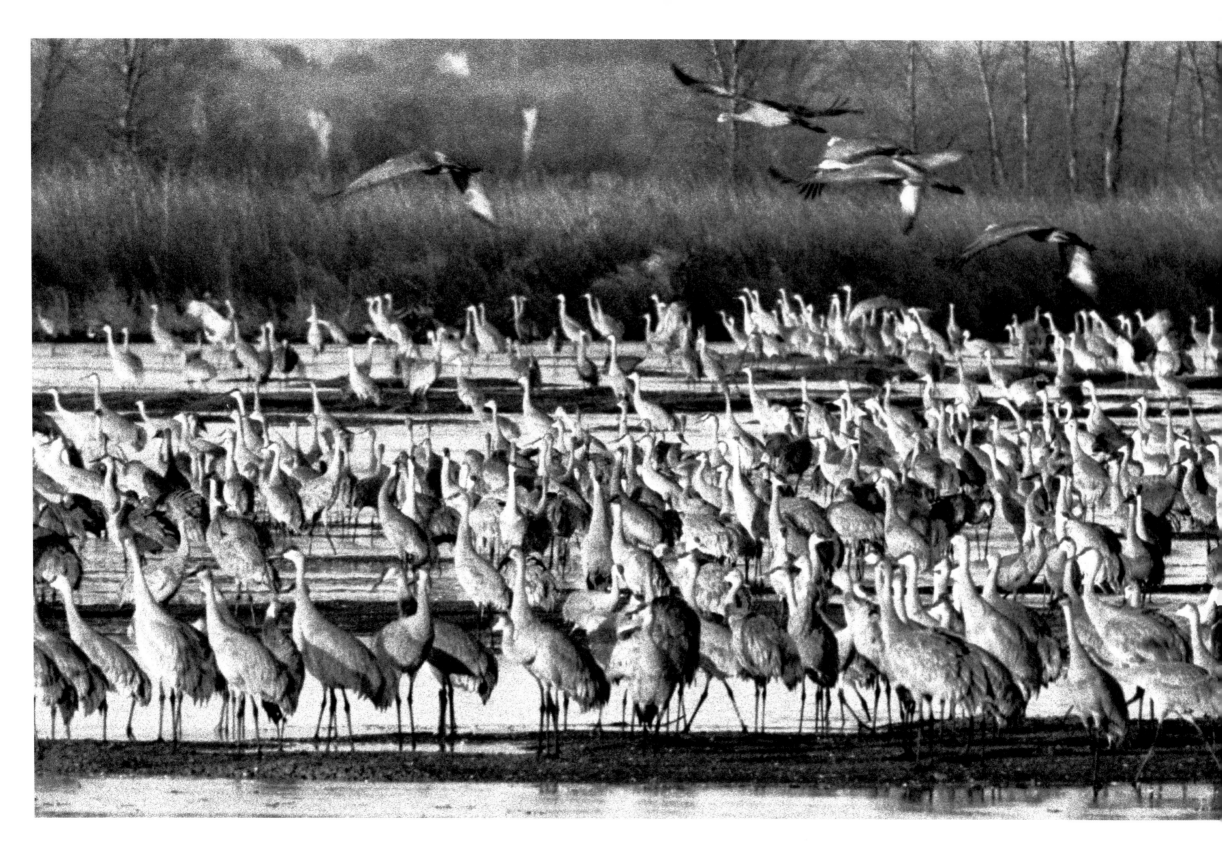

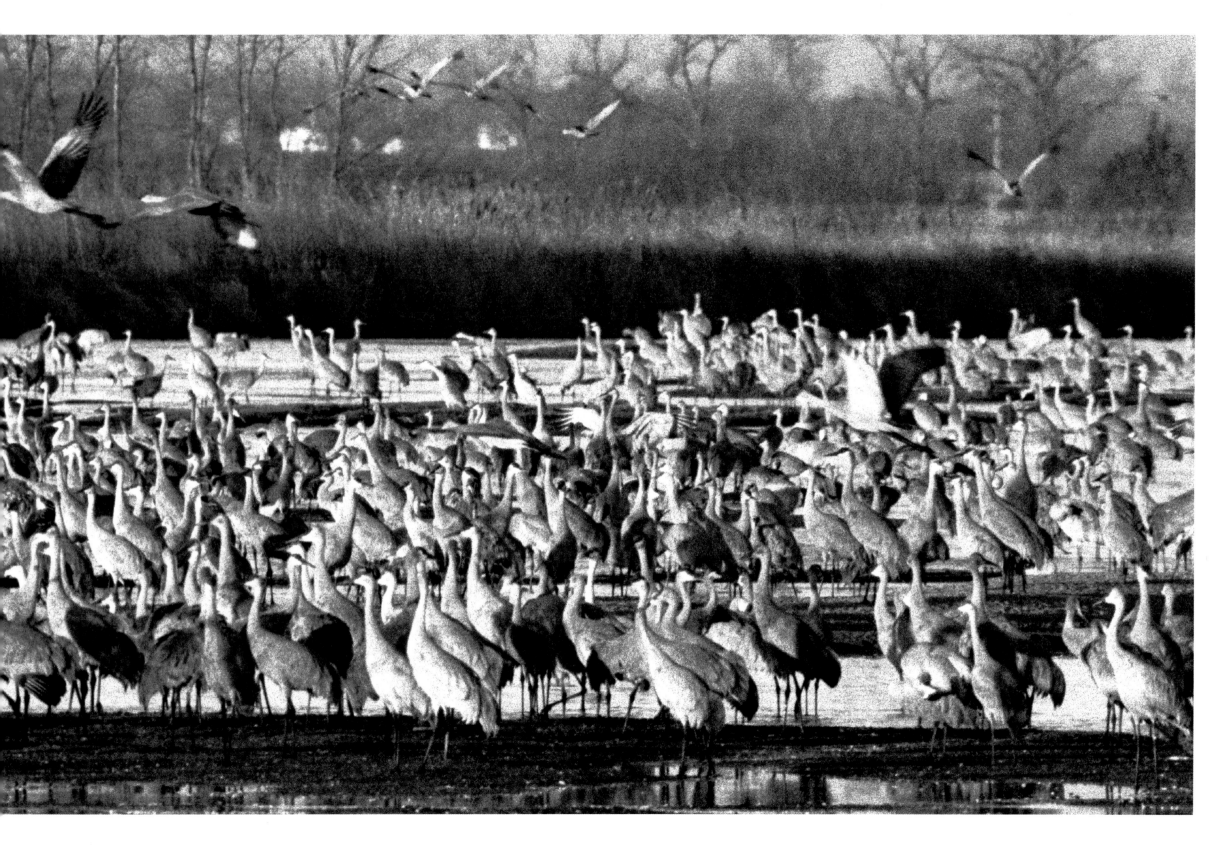

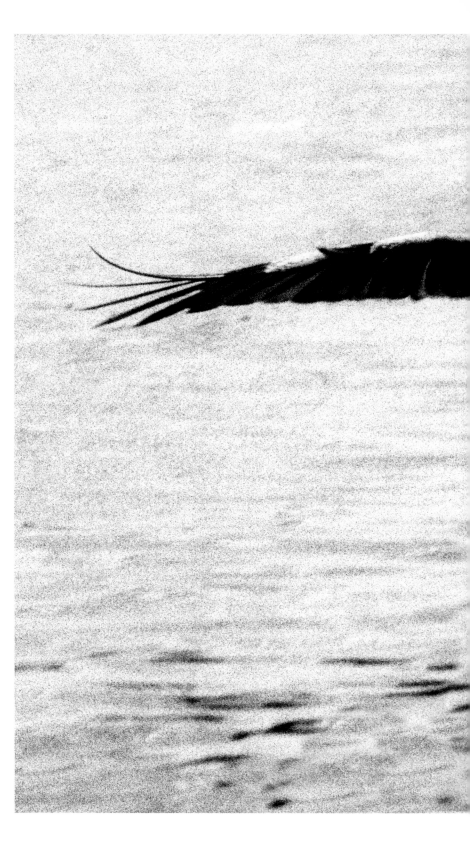

Brown Pelican landing, Sarasota Bay, Sarasota, Florida, 1998

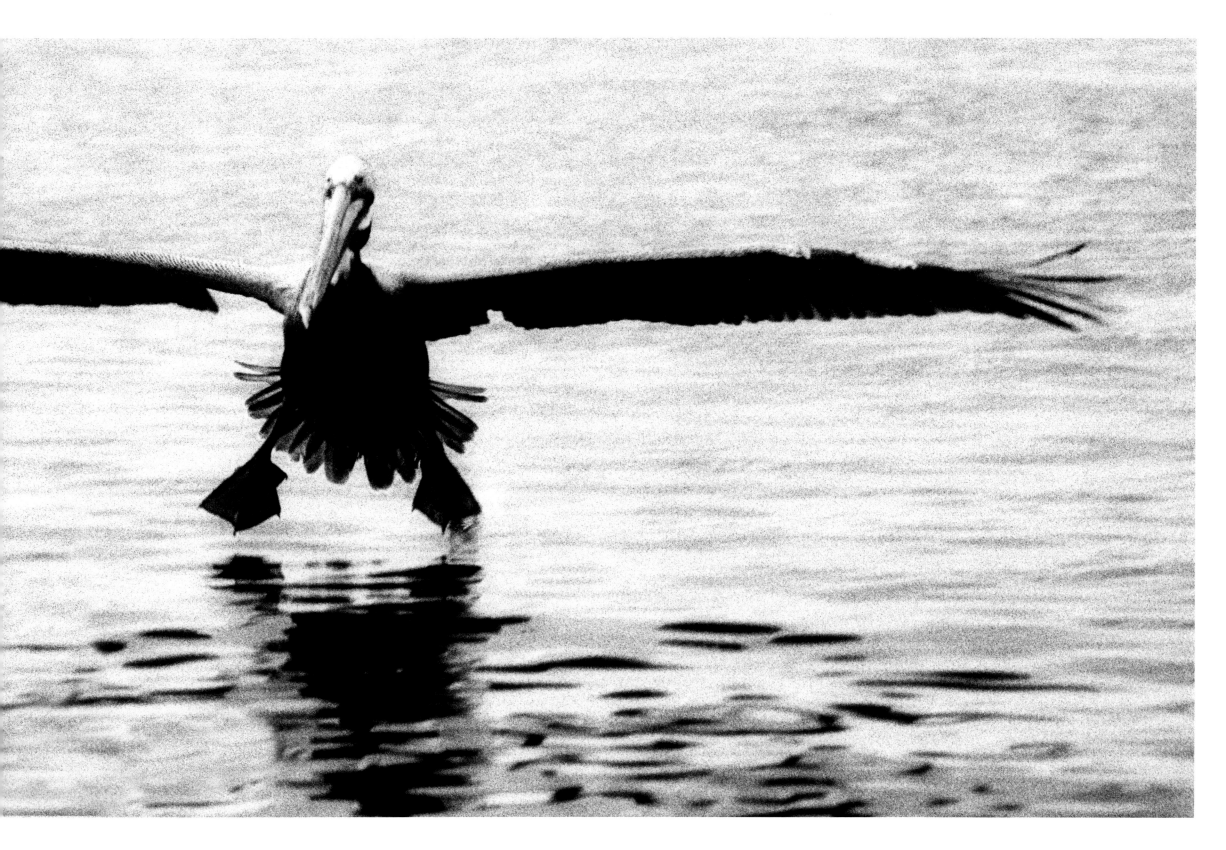

In order to see birds, it is necessary to become part of the silence.

— roger tory peterson

Great Egret, St. Petersburg, Florida, 1999

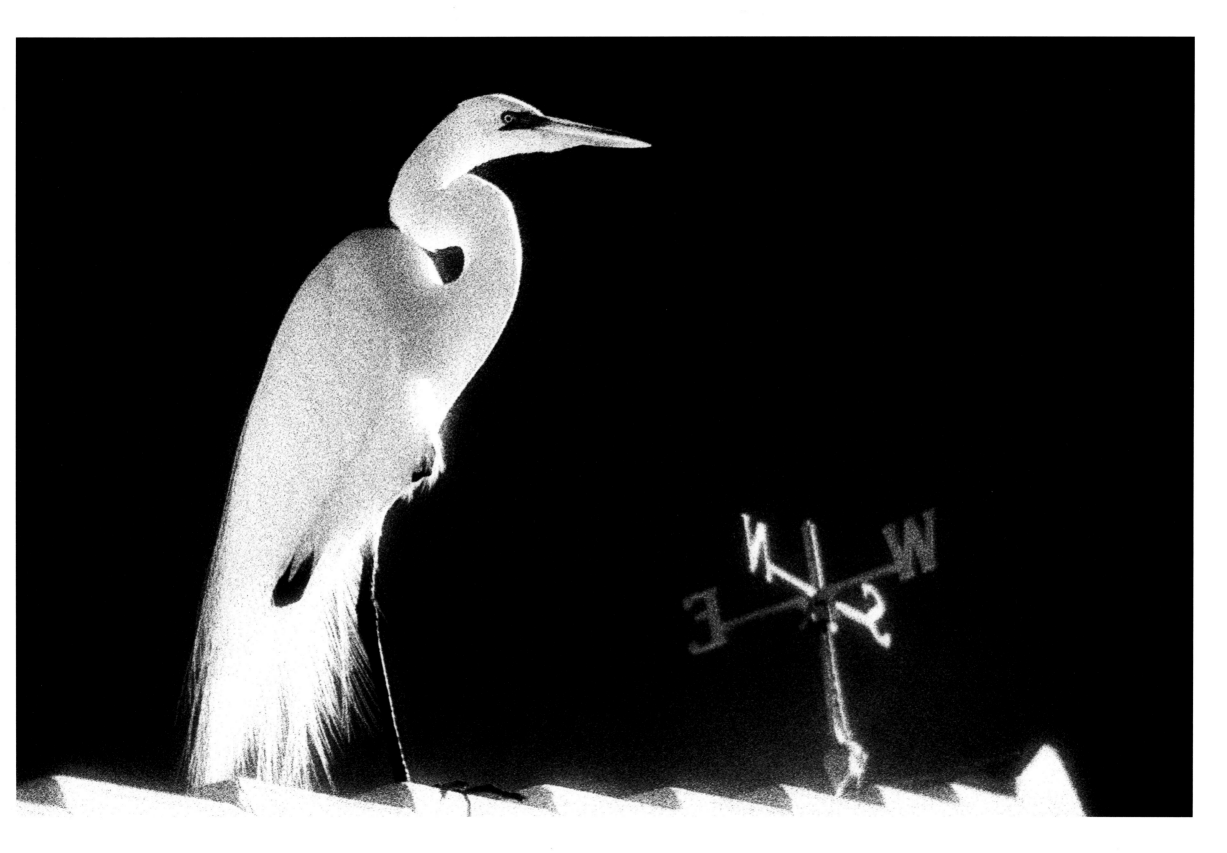

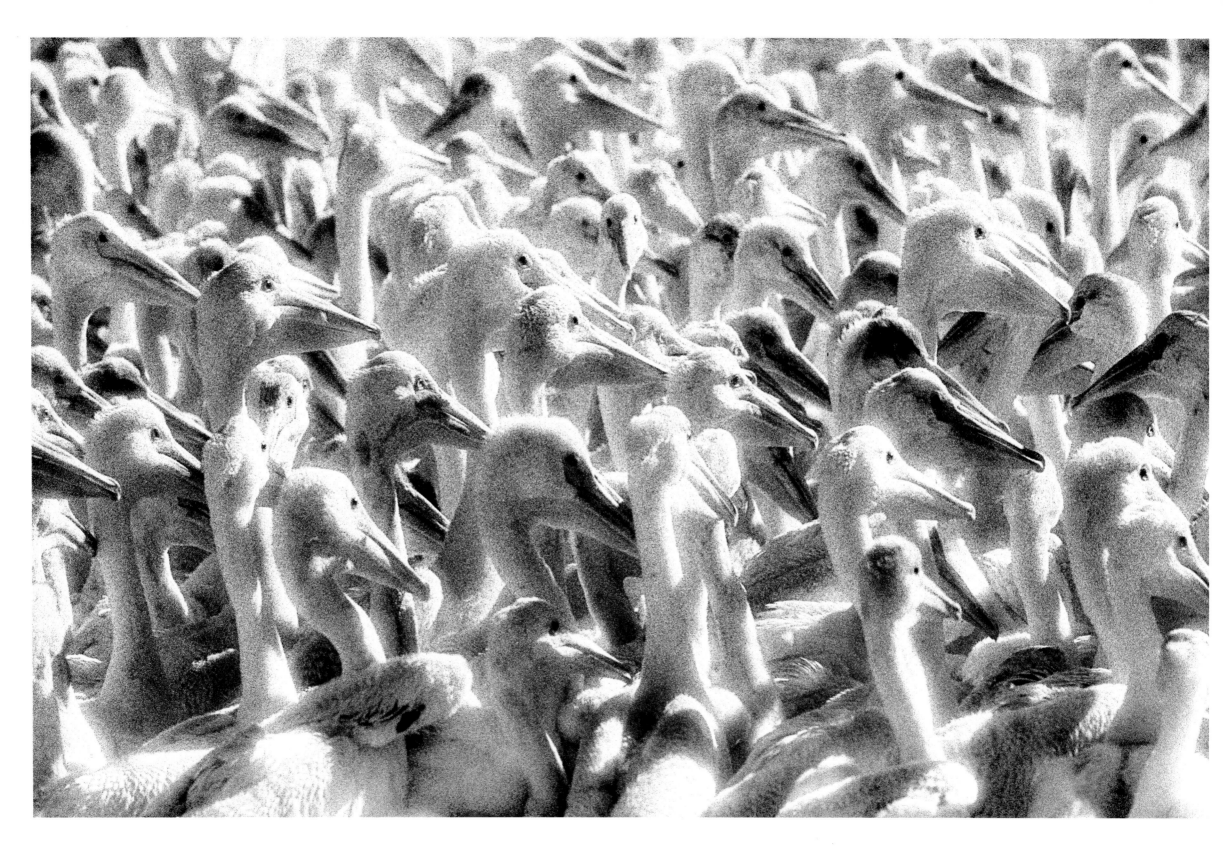

afterword

ROSALIE WINARD

there are no
 letters, there is no
 telegraph
between poet and bird:
there is secret music,
only hidden wings,
plumage and power.

— Pablo Neruda, from "The Stones and the Birds"

It was the spring of my freshman year of college when I opened my heart to the birds. I was seventeen, sitting on a sea wall, watching the sunrise. I had never paid attention to light, especially not to the magic of a breaking day. A cloudless morning, the bay waters of the Gulf of Mexico were still.

Off in the distance a solitary brown pelican appeared. I watched him fly closer and closer. He looked like a prehistoric creature, yet he dove for fish with the grace and accuracy of a thrown javelin. I did not know then that his bones were hollow and that his species was forty million years old.

For months I had been living in Florida, a state brimming with birds, yet my energetic, adolescent mind had barely registered them. That morning as I watched the pelican's ancient form dip and glide, the world slowed down for the very first time.

Once pelicans had entered my consciousness, they would not go away. On daily bike rides along Bay Shore Road, in the library looking out the window, on the water in canoes, always the pelicans…

It was in an environmental biology course that binoculars became my second set of eyes. For hours, on a tiny, unnamed island in Sarasota's Roberts Bay, I observed and took notes on pelican behavior—flying, fishing, preening. I saw them incubating their eggs, feeding their chicks, greeting their mates and protecting their nests. I collected broken eggshells and dead pelican chicks that fell from their nests to be analyzed for DDT residue. The paradox of the pelicans' gawkiness on the ground and their graceful elegance in the air utterly absorbed me…I felt I was learning a new language.

I didn't know then that my work with pelicans was changing the course of my life, pulling it into focus and bestowing upon me the space to be quiet and breathe. Calm. I didn't know stillness until I spent hundreds of hours observing birds, counting birds. Since that dawn in 1970, when the word *ecology* was a faint whisper, almost unheard of, I have kept my eyes toward the sky.

The first white pelicans I ever saw appeared above the highway north of Salt Lake City. It was late summer in Utah. I was on my way to the Bear River Bird Refuge when I noticed these white dots silhouetted against the distant Wasatch Mountains. The dots flew nearer and nearer. I drove past my exit, transfixed, eyes clearly not on the road. Finally, I could discern their familiar pelican shape, this time in white and black, before they flew higher and higher, thousands of feet above the mountains, riding a thermal. Before I realized I was lost, I had counted seventeen white pelicans.

I found my way back to the Bear River Refuge, a stopping point for millions of

migrating birds along the Great Salt Lake. My first impression was one of complete stillness. I was, as far as I could tell, the only person out there. I stayed in the car. Forty feet away from me were a flock of twenty-two white pelicans in the river and on the banks. One of the birds stood and stretched its wings and shook its head, its wingspan was greater than a whooping crane's. Happiness flowed through me, not the giddy kind, but a calm happiness that told me I was just where I belonged. The same feeling I'd experienced years earlier in Florida watching the solitary brown pelican.

I was startled to discover the way white pelicans fished. They are synchronized swimmers at their best. Think Esther Williams with feathers. I had assumed they dove for their food like brown pelicans. They do not. White pelicans float on the water in groups large and small. Moving in a circle, oval or line formation, they herd the fish, and then in unison dip their heads and necks into the water. Gliding, submerging, rising, some with fish in their bills, some not.

Mesmerized, I lingered until the sun faded.

There was no logic to my travels. I went where my intuition led or where I was welcomed. Much to my delight, I frequently witnessed new behaviors as I migrated. In Louisiana on a hot, bright day I saw a wood stork submerged in the river up to its breast feathers, with one wing extended fully out over the water. I realized the overhanging wing provided a shadow for fish to swim into and watched as the stork lured in its prey.

In my travels I have been pushed to the edge. I caught myself one afternoon repeating the mantra "mosquitoes are my friends" to quiet myself so I could stay on a causeway and shoot avocets.

I've spent the night in a blind surrounded by the voices of sandhill cranes on the Platte River in Nebraska during their spring migration. Thousands of birds calling out simultaneously in an ongoing exchange of varying pitches and rhythms—a cacophony of communication. By dawn, one could discern the call and response of individual birds above the symphonic buzz.

But more and more I hear a growing silence in the avian world.

In 2004, when I photographed the pelicans at Chase Lake in North Dakota, 30,000 birds were counted there. In 2005, the colony was devastated. For the first time in one hundred years of recorded data all the white pelicans abandoned their nests containing eggs and chicks. Not a single chick was fledged that year. In 2004, I observed the world's largest breeding population of white-faced ibises on the Great Salt Lake, only to find that the summer of 2007 was a near wash-out for them. In 2006, two years after I was at Lake Martin in Louisiana, thousands of birds—roseate spoonbills, anhingas, cormorants, little blue herons, great and snowy egrets—abandoned the rookery before their eggs were even laid.

Why are the birds fleeing? Where are they going? Where can they go?

On Gunnison Island, in the west end of the Great Salt Lake, the white pelican colony is now seriously threatened by mining expansion. A lease has been granted to expand a potassium sulfate mining operation on thirty-six square miles of the lake's west end. Fourteen environmental groups are fighting to prevent this. They are worried about the expansion's potential effects on 250 species, including five million birds, that live in or around the lake.

We developed as a species in a world full of birds. We live on a delicate planet, amidst a delicate balance of species.

I have encountered people who are afraid of birds, people who are indifferent to birds, and people who would lay down their lives for birds. I have seen the best and worst humanity has to offer, played out in the fight over wilderness preservation. Yet the pollution, destruction and encroachment continue.

I am left struggling with the question: *How will birds survive in the future?*

I have always wanted to depict how birds make me feel…what I see in them… what moves me about them…I strive in my images to emphasize birds as individuals and as part of a community and habitat. I've seen them across America. 30,000 white pelicans; 500,000 sandhill cranes; 800,000 Wilson's phalaropes…numbers I never dreamed of seeing…

I hope that my love for these birds is contagious and that my work is a call to preserve the wetlands and their inhabitants.

Brown Pelican, Longboat Key, Sarasota, Florida, 1997

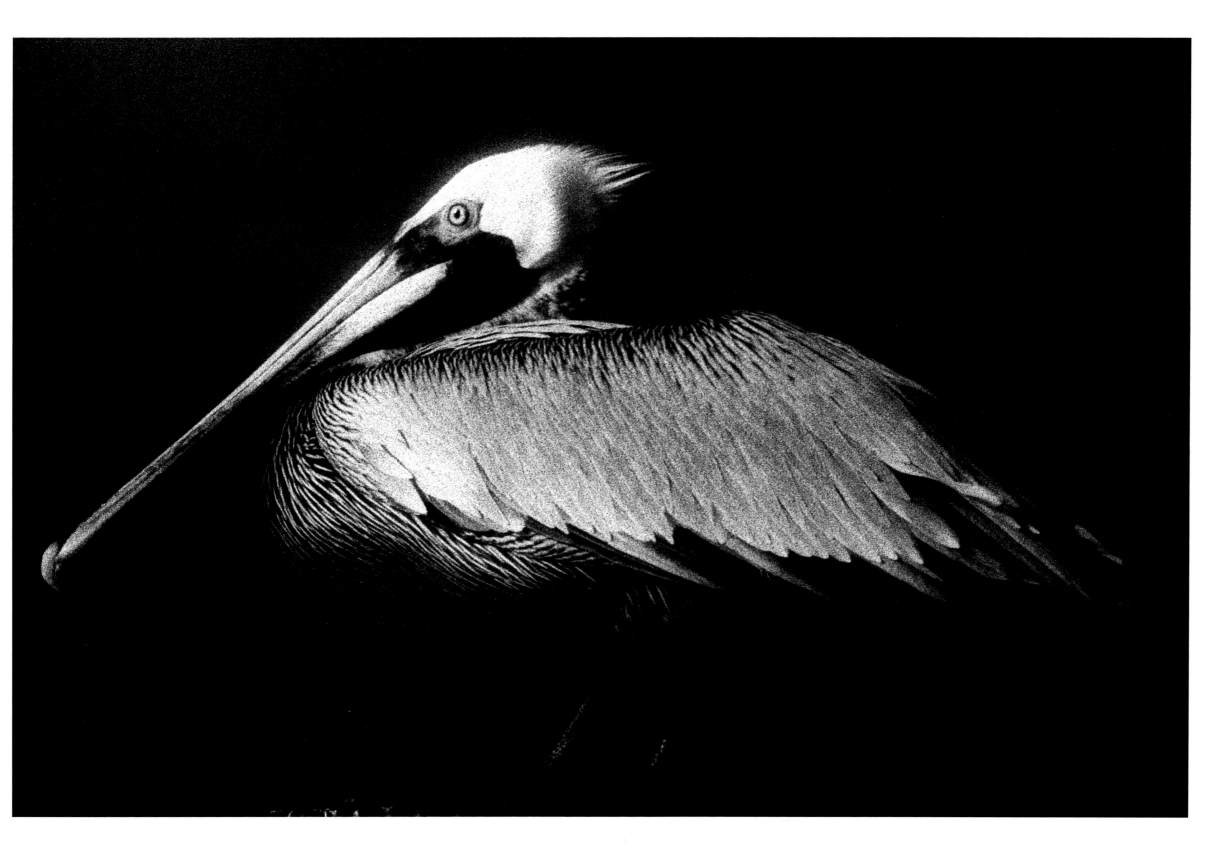

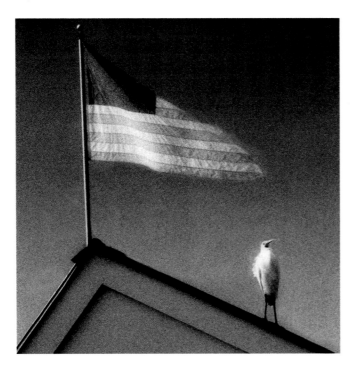

This book is dedicated to
EMILY BADILLO-WINARD

PAGE ONE: Great Egret, New Pass, Sarasota, Florida, 1997

PAGE TWO: Sandhill Cranes and Canada Geese, Platte River Valley near Grand Island, Nebraska, 2003

LEFT: Snowy Egret, Anna Maria Island, Florida, 1999

Published in 2008 by Welcome Books®
An imprint of Welcome Enterprises, Inc.
6 West 18th Street, New York, NY, 10011
(212) 989-3200; fax (212) 989-3205
www.welcomebooks.com

Publisher: Lena Tabori
Editor: Katrina Fried
Editorial Assistant: Kara Mason
Designer: Gregory Wakabayashi

Digital scans of the original negatives by Print Edge (New York) under the direction of Patrick Cline

Library of Congress Cataloging-in-Publication Data

Winard; Rosalie.
 Wild birds of the American wetlands / by Rosalie Winard ; foreword by Temple Grandin ; introduction by Terry Tempest Williams. -- 1st ed.
 p. cm.
 ISBN-13: 978-1-59962-034-3
 ISBN-10: 1-59962-034-0
 1. Photography of birds--United States. 2. Birds--United States--Pictorial works. 3. Wetlands--United States--Pictorial works. I. Title.
 TR729.B5W56 2008
 779'.328--dc22

 2007043713

First Edition
10 9 8 7 6 5 4 3 2 1

Printed in China

acknowledgments

Profound thanks to a flock without whom this book would not have fledged—Geralyn Dreyfous, Judith Goldman, Anne Milliken, Jono Miller, Julie Morris, Lena Tabori and Terry Tempest Williams. Terry helped me return to the core of my self. Creating the physical body of *Wild Birds* was remarkably facilitated and greatly enhanced by the patience and guidance of Katrina Fried and the gift of Gregory Wakabayashi's exquisite eye and calm.

There are many people and organizations without whose encouragement, help, and support my travels and this book would not have been possible. My gratitude is unbounded.

In Florida—Chris Becker; Amelia Bird; Andrea Bishop; Kristi Candelora; Dr. Paul Carlson; Jake & John Cranor; Double C Bar Ranch; Marty Folk; Ruth Folit & Dr. Marc Weinberg; Lee & Samantha Harrison; Capt. Lance Leonard; Emily Mann; Dr. John B. Morrill; the Mote Marine Laboratory; Dr. Steve Nesbitt; New College of Florida; the late Kay von Schmidt; the late Dr. Ralph Schreiber; and Ginny, John, Tom & Jessie Skorupski of the Olde Fish House Marina.

In California—Tim Anderson & Le Bateau du Audubon; Lenny Arkinstall & Los Cerritos Wetlands Stewards; Peter Barnes & Mesa Refuge; Pam Carr; Marcia Hanscom & Roy van de Hoek of the Wetlands Action Network; Eileen Murphy, Connie Boardman & Marinka Horack of the Bolsa Chica Land Trust; Taylor Parker; Claire Peaslee; Susan Suntree; and Jan Williamson.

In Louisiana—Mary Lynn Chauffe & Bayou Teche Bed & Breakfast; Elaine Fortier; Danny Izzo; and Marc & Ann Savoy.

In Nebraska—Tricia Beem; Dave Brandt; Dr. Felipe Chavez-Ramirez; the late Dr. Paul Currier; Beth Goldowitz; Grand Island/Hall County Convention & Visitors Bureau; James Jenniges; Donna Narber; the Platte River Whooping Crane Maintenance Trust; the Rowe Sanctuary; Renee & Bernie Seifert; and Paul Tebbel.

In North Dakota—Mick Erickson; Deb & Craig Hoffmann; and Dr. Tommy King & Dr. Marsha Sovada of the USGS Northern Prairie Wildlife Research Center.

In Utah—Borge Andersen Photo • Digital; Molly Crile; Lynn & Patrick de Freitas; Phil Douglas; Geralyn & Jim Dreyfous; Environmental Humanities/College of Humanities/The University of Utah; Friends of the Great Salt Lake; Thayne Gerhart of the Chesapeake Duck Club; Great Salt Lake Bird Festival; Rich Hansen; Jolene Hatch; Helena Levier; John Luft; Becky Menlove & the Utah Museum of Natural History; Anne & John Milliken; Julie Moore; Anne Neville; Robert & Vicki Newman; Don Paul; Joel Peterson; Donna Poulton; Salt Lake City Film Center; Jeff Salt; Stephen Swindle; Kathryn Toll; Tracy Aviary & Tim Brown; Utah Open Lands; Anne Watson; Brooke Williams; and Jeff Wright & Jennifer Shorter of W Communications.

In Wisconsin—Dr. George Archibald, Jeb Barzen, Curt Meine & Mary Ann Wellington of the International Crane Foundation.

In addition, I'd like to thank Dr. Charles Benbrook of Benbrook Consultant Services; Hugh Carola of the Hackensack Riverkeeper, Inc.; Cannon Professional Services & Dave Sparer; Chisholm Larsson Gallery; Miriam Faugno of the Jersey City Reservoir Preservation Alliance; Robert F. Kennedy, Jr. & Mary Beth Postman of Waterkeeper Alliance; Kara Mason, Eric Norgaard & Wade Slitkin of Welcome Books; *Parabola* magazine; Carolyn Raffensberger of the Science & Environmental Health Network; Leslie Reed-Evans of the Williamstown Rural Lands Foundation; John Stuart; and Lélia and Sebastião Salgado, founders of the Instituto Terra.

And I would like to express special gratitude to my friends and family—Yvonne Adrian; Diana Barrett; Sue Barry; Terry Bisson; Zana Briski; Dr. Michael Cindrich; Patrick Cline; Kate Edgar; Miriam & Vivian Epstein; Alexis Finlay; Allen Furbeck; Lauren Goodsmith; Jean Graham; Temple Grandin; Andy Gurian; Judy Jensen; Juris & Rosa Jurjevics; Barbara Kane; Martha Kaplan; Shelia Kimball; David LaMarche; Mara Lurie; Quintessa, Selena & Stuart Matranga; Mary McClean; Cindy Mozlin; Carol, Norman, Dylan & Sophia Moore; Mary R. Morgan; Errol Morris; Tom Nimen; Jimmy Ortiz; Clara & David Park; Rachel Park & Drew Failes; Mary Parkin; Kristy Reichert; Oliver Sacks; Susan Scanga; Peggy & Bill Schwartz; Jed Schwartz; Linda Stackhouse; Ana Taras; John Weber; Allan & Ellen Wexler; Adrienne Wootters; and of course my parents, Arthur I. and the late Esther Winard. —R. W.